Colorama

Colorama

THE WORLD'S LARGEST PHOTOGRAPHS From Kodak and the George Eastman House Collection

Essays by Alison Nordström and Peggy Roalf

•

APERTURE FOUNDATION

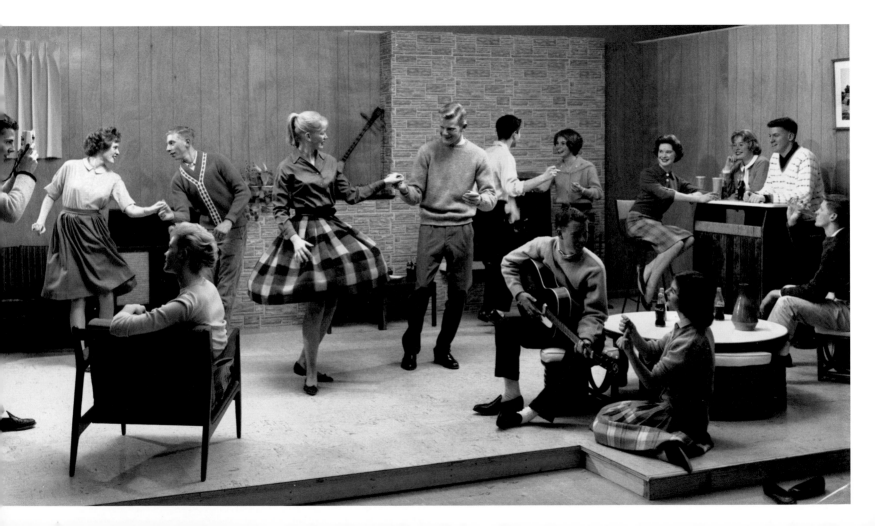

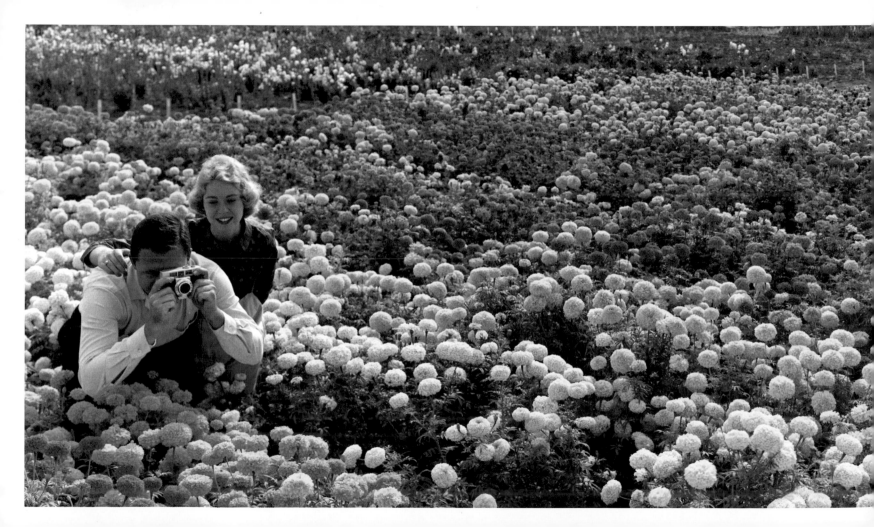

DREAMING IN COLOR Alison Nordström

If you had been in Grand Central Terminal on any weekday morning during the Cold War years, you would have seen an army of white-collar workers arriving to populate the offices of America's most driven city. On the station's great east wall, looming above the commuting multitudes, you might have caught sight of a huge illuminated image of gargantuan spring flowers, sublime mountain vistas, or attractive people frozen in the cheerful and stylized rituals of suburban life. In this massive building that was part basilica, part kicked anthill, these big, bright pictures were a still, constant, and resonating presence, offering, perhaps, an escapist portal for the men in their gray flannel suits streaming in from the suburbs.

In 1950, Eastman Kodak Company installed the first Colorama in Grand Central. These advertisements would become known as "The World's Largest Photographs" and were huge indeed: eighteen feet high and sixty feet wide, requiring more than a mile of cold-cathode tubes to illuminate the transparencies from behind. Altogether, 565 Colorama photographs would be situated on this spot over the next forty years. As a major corporate and aesthetic undertaking, the production of Coloramas required the combined efforts of Kodak's marketing and technical staffs and scores of photographers that included such notables as Ansel Adams, Ernst Haas, and Eliot Porter. Until 1990, these illuminated images reflected and reinforced American values and aspirations while encouraging picture-taking as an essential aspect of leisure, travel, and family. In the decades that came and went—from Levittowns and the baby boom, to Watts and Woodstock, to video games and MTV—they proffered an almost unchanging vision of landscapes, villages, and families, American power and patriotism, and the decorative sentimentality of babies, puppies, and kittens. They marked traditional holidays, conventional views of the faraway, and such uplifting events as a moonwalk and a royal wedding; they suggested, with varying degrees of explicitness, that such sights could be defined, secured, memorialized, and enjoyed through the complementary practice of photography. "Everyone who sees the Colorama," said Adolph Stuber, Kodak's vice president of sales and advertising when the project was conceived, "should be able to visualize themselves as being able to make the same wonderful photo." Today, these images linger in the landscape

●

Marigold field, Harris Seed Farm,
Gates, New York.
Colorama #210 by Dick Boden,
September 1962

Front cover:
Making movies in Yosemite
National Park, California.
Colorama #344 by Peter Gales,
August 1970

Title page: Teen dance
in basement recreation room.
Colorama #193 by
Lee Howick and Neil Montanus,
October 1961

of memory. The Coloramas taught us not only what to photograph, but how to see the world as though it were a photograph. They served to manifest and visualize values that even then were understood as nostalgic and in jeopardy, salvageable only through the time-defying alchemy of Kodak cameras and film.

The Grand Central building was a fitting locus for such aspirational statements. As characterized in the popular 1940s radio drama that bore the terminal's name, it was the "heart of the country's greatest city . . . crossroads of a million private lives, [a] gigantic stage on which are played a thousand dramas daily." The structure was an acknowledged Beaux Arts masterpiece, patterned, without irony, on the Roman Imperial baths. It was New York's largest interior space, moving, in its heyday, more than five hundred trains and half a million passengers daily.

But the city's postwar demographic shift to the suburbs and the automobile was not supportive of Grand Central's prewar elegance. For a deteriorating rail industry, the revenue from the sale of its terminal's walls as advertising space was attractive, and for Kodak, long a leader in marketing, the opportunity to claim such a high-profile space to present a technical tour de force was an exciting prospect. The commercial justification of such an undertaking is evident, but the tone of its participants' reminiscences suggests that, for many of them, the campaign was more like a religious experience. "You are here to promote photography," Vice President Stuber told his staff. "Talk photography first—Kodak next." Kodak veterans describe these ambitious installations as "displays of renewal and accomplishment," "a panoramic picture gallery of human experiences," "a mirror of American aspirations," "an upbeat affirmation," and "a record of wonders."

The roots of the Colorama are fixed in spectacle. In an age where tail fins, skyscrapers, and Cinemascope evinced the triumphs of both scale and technology, the biggest example of anything was worthy of note. In photography, lifelike color was still a novelty. Kodak's *Cavalcade of Color*, an extravagant presentation of gigantic slide projections, had been immensely popular at the 1939 World's Fair. The first proposal for the space at Grand Central had been for a similar display, until it became clear that the varying ambient light inside the station would impair the impact of projected images. The solution of back-lit color transparencies was determined well before the technical problems of their production had been resolved.

The east end of the building's main concourse had maintained a mammoth and uplifting photographic presence as early as 1942, when a four-panel display of twenty-two enlarged Farm Security Administration photographs was installed to encourage the purchase of Defense Bonds. It remained a fixture until the end of the war. The codes of scale, zeal, and visual drama were thus well established at the Colorama site long before the patriotic fervor of World War II was replaced by the optimistic consumerism of the 1950s.

In the Colorama's first decades, the overt motif was photography itself, and—regardless of setting—the images depicted people with cameras in picture-

worthy scenes well into the 1970s. The very first Colorama showed two rosy-cheeked, red-clad children amid yellow-flowering trees, being photographed by their mother, who sports the same trademark Kodak colors. The picture emphasizes the time-stopping, memory-creating aspects of family photographic practice, as does another image, first shown July 10, 1950, of a farm and a three-generation family in a horse-drawn wagon, posing for the father's camera. It is flanked by two deckle-edged snapshots of the same people in different poses, suggesting what the memory of that afternoon will look like. In 1951, Ansel Adams's *Yosemite in Snapshots* depicted a brightly dressed family group being photographed by another, against a magnificent backdrop of mountains, waterfall, and sky. Adams later called his Colorama work "aesthetically inconsequential but technically remarkable." Some Kodak staff objected to the choice of a photograph in which the act of making the image upstaged the photograph's grand subject, but the management response was, "Colorama should not be ambiguous in promoting the excitement of color photography."

 Over the following years, Coloramas showcased photography as a social activity, a welcome and inevitable part of sock hops, barn dances, birthday parties, Thanksgiving dinners, weddings, hunting trips, ski trips, and holidays abroad, in which the act of taking pictures became a means of heightened enjoyment and participation. The Coloramas also showed that perusing the pictures later on could be as much of an idealized family activity as the making of them. *The Snapshot Album* and *Projecting Slides at Home* show photographs in use as family entertainment. Like the gigantic faux-snapshots that frame most of the early Colorama scenes, these images encourage the picture-maker to imagine the present as a past to be appreciated in the future.

 The people with cameras who populated Coloramas were invariably happy amateurs taking pictures as a regular and enjoyable part of their leisure activities. They were often shown with their families, who provided either subject or audience. For decades, families and couples happily golfed, fished, picnicked, and danced before a loving lens. Often the family's activity was simply to pose—wading in a brook, strolling through a garden, or sitting in picturesque arrangement on a stone wall, while one of them photographs the rest. Frequently, one person is shown photographing something else while family members eagerly look on. Both women and men are shown as family photographers, but men are shown more than twice as often. In the ordered hierarchy of the Colorama, men photograph women, women photograph children, children photograph other children, and everybody photographs a scenic view.

 In Coloramas, families most commonly consist of comely, athletic young parents, with two children, usually a boy and a girl. When this family is expanded, it includes one or more grandparents, often in nostalgic roles requiring old-fashioned or bucolic settings. If only one parent is pictured it is the mother, photographing her winsome young children playing outdoors or at a birthday party. Also popular are images of young couples, one of whom is carrying or using a camera, often in romantic settings involving rowboats or masses of flowers. Slightly older couples appear in more affluent

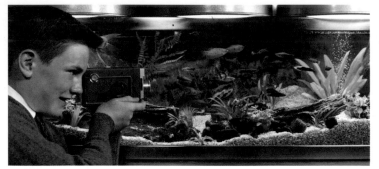

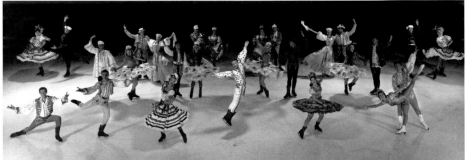

From left: Making movies of the fish. Colorama #200 by Ralph Amdursky, February 1962

The Ice Capades. Colorama #158 by Bob Phillips, September 1959

•

recreational environments, and always in the company of other couples: on a moored yacht in Fort Lauderdale or on the golf course. Elsewhere, groups of teenagers dance, picnic, camp, ride, and surf—their demeanor and appearance changing minimally over the century's most tumultuous and transformative decades. Foreign travel destinations come to prominence as Colorama subjects after 1965, just at the time when inexpensive air travel encouraged many Americans to venture abroad for the first time. Early images (the harbor at Rio de Janeiro, a parade at Windsor Castle) show tourists happily snapping instant memories. Later images emphasize the scenic beauties of such easily recognized icons as Mount Fuji, Machu Picchu, the Taj Mahal, and the Acropolis.

From the beginning, both Kodak and its audience treated the Colorama as more than an illuminated billboard. The first image premiered with a formal unveiling, speeches, and applause. Six months later, a skillfully lit image of wholesome young people at a barn dance moved Edward Steichen, then director of the Museum of Modern Art's photography department, to telegraph Kodak: EVERYONE IN GRAND CENTRAL AGOG AND SMILING. ALL JUST FEELING GOOD. In the decades that followed, the unveiling of other Coloramas was an opportunity for pageantry and special effects. The Marine Drum and Bugle Corps performed before a picture of the Marine Memorial that later, as part of a Radio City Music Hall stage show, brought forth many a standing ovation. A member of the Navy's Blue Angels precision aerial team, invited to be present when a stirring image of jets in flight was first shown in 1959, describes late-night commuters on the concourse floor stopping to applaud. In 1977, members of the Dutch diplomatic corps participated at the opening ceremony of a Colorama featuring a mammoth still life of Dutch irises and daffodils. In 1980, at the unveiling of a view of the Irish countryside,

the New York Police Force Bagpipe Band ambushed a speech by the Irish Consul with a loud, enthusiastic, and unauthorized parade around the concourse.

Colorama was a spectacle in itself, but the notion of spectacle and theatricality is also apparent in much of the subject matter of these mammoth, iconic images. Performances were common subjects, from the New York City Ballet to the Rockettes, the Royal Academy of Thai Classical Dancing, and the Ice Capades. Theme parks, including Knott's Berry Farm, Universal Studios, Sea World, and Disneyland, were a particularly popular subject after 1970. Images of World's Fairs in 1965 and 1967 continued a long tradition of Kodak sponsorship of such flamboyant photographic subjects that had begun as early as 1893. As the decades proceeded, Colorama reinforced the hyperrealities of such omnipresent fictional and quasi-fictional television characters as Ozzie and Harriet Nelson, Ed Sullivan, and Mickey Mouse. The Nelson family, stars of Kodak's first successful television sponsorship, appeared four times in Colorama tableaux between 1956 and 1960—once onstage with Ed Sullivan and once in Waikiki, with the family posing on the beach as Harriet does the hula, Ricky plays guitar, and Ozzie makes a home movie.

The Colorama format exaggerated the epic presentation of things in rows: midshipmen, choirboys, babies, fighter jets, gondolas, iceboats, koalas, kittens, and tulips were all graphically displayed in rhythmic and gargantuan array. Their unique size and shape also supported content with such imposing subjects as the Brooklyn Bridge, Niagara Falls, and the Grand Canyon, photographed so that their huge and sweeping horizontality reinforced the inherent grandiosity of the Colorama itself. Yet while epic landscapes remained popular throughout Colorama's history, another dominant theme was a stylized presentation of an imagined American past, performed as nostalgic tableaux, with their roots in the popular chromolithographs of the Gilded Age parlor. Early Coloramas of this type were conceived by Kodak art directors as watercolor illustrations. They had a distinctly local flavor. The farm scene unveiled in July, 1950, for example, used a number of Kodak personnel and their families as models. The image of the barn dance that so delighted Steichen depicted thirty-two Rochester high school students. Later illustrations of this type were professionally designed. Norman Rockwell's 1957 *Closing up a Summer Cottage* constructs a line of sentimental little dramas—each suitable for a cover of *The Saturday Evening Post*—across the monumental Colorama stage.

Coloramas resonate with nostalgia, a staple in Kodak advertising since at least 1900, reminding us to pause, via photography, in the midst of present enjoyment to record it for later remembrance. In its role as an architectural and geographical landmark, the Colorama became a major producer of nostalgia—including, eventually, for itself—as certain repeated ideas became leitmotifs. Kodak's relentless depiction of a gentler, simpler, better time was intended to influence the ways its consumers understood photography. Its enduring presence and recurring subjects—Olympic opening ceremonies, New England villages in snow, baby birds, smiling families—transformed the Colorama itself into a source of comforting continuity in the heart of the world's busiest city.

Coloramas served to educate the public as to what subjects merited photographic memorialization. In several, objects from the past, such as those in an old-fashioned kitchen or attic, are arrayed for the modern camera and its equally up-to-date user. In others, transient moments—the high-kicking dance moves of teenagers at play, or mothers and children around a birthday table—are frozen by a self-conscious performance for an audience that necessarily includes the picture-taker. The images are not candid; rather, they show people happily acknowledging photography's role in enhancing the everyday. Codes of behavior are clear; at the birthday party, the applause may be for the cake, but the joyful faces are focused on the camera.

Many Coloramas celebrated particular seasons and holidays. Halloween, Thanksgiving, Memorial Day, and Independence Day appeared sporadically and in a variety of ways, but Christmas was presented faithfully every year as a holiday greeting card. Images ranged from choirs to winter scenes to several variations of families on Christmas morning (in which a Kodak camera was, of course, the most exciting gift). Certain seasonal rituals were peculiar to the culture of Grand Central Station itself, such as the early July transfer of New York children to their sign-carrying chaperones for train trips to hundreds of summer camps. Kodak oversaw this annual exodus with idyllic images of camp activities and their photographic recording. Beneath the Colorama's memorializing gaze, the gray flannel-suited dads, whose daily toil enabled this ceremony of suburban youth, were validated by this fantasy nod to the ideal calendars of their families' lives.

Well into the 1980s, the Coloramas' audience was made up of the predominantly white, male commuters passing through Grand Central en route between suburban family life and city offices, yet the life of the city rarely figures into these images. Cities, if presented at all, are silent skylines seen from a distance, and usually after dark. Especially in the years before the early 1970s, Coloramas offered commuters escapist fantasies of the idealized world that justified their labor. This perfected vision of America would persist strongly in Coloramas through the decades of generation gap, women's liberation, and a deeply divisive war—a measure not of its literal truth but of its power. These were images that could be read at a glance, intended to evoke and confirm a common vocabulary, and possibly bring forth a momentary "Wow!" The desire for "photographic appeal and general interest" that had shaped the first Colorama lasted to the end.

When change over time is at all evident in the forty years of Coloramas, it is a dim reflection of the dramatic transformations occurring in the rest of the world. Thus, a Christmas choir shown in 1952 features rows of surplice-clad white boys. In 1962, a year before the publication of Betty Friedan's *The Feminine Mystique*, a new image added white girls to the chorus. In 1969, as race riots tore through America's cities, a third version showed a racially mixed array of boys and girls. The first African-American models appear prominently in a Colorama in 1969, in a spring scene of two couples enjoying a tulip garden. To Kodak's surprise, the image generated some nasty letters. Later Coloramas relied less on the conventions of illustrators' tableaux

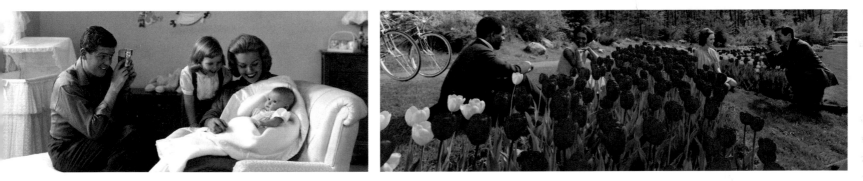

From left: The new baby.
Colorama #180 by C.O. Baker,
February 1961

Sterling Gardens, Tuxedo, New York.
Colorama #319 by Norm Kerr,
February 1969

and more in favor of a somewhat candid look, but their message continued to be the celebration of family events—Christmas, graduations, weddings, vacations—and a reassuring and romantic vision of faraway places.

The 1990 renovation of Grand Central Station Terminal to landmark condition marked the end of what some saw as jarring commercial displays and others remember with great fondness. In the years after the Colorama's removal, the terminal still held its purposeful bustle of commuters, though now the swarm is marked by more women and more people of color—and, perhaps, a loss of innocence and simplicity we can now scarcely imagine. Today, amid the visual noise of New York's Times Square and Tokyo's Shibuya Crossing, it is hard to grasp the original impact of a solitary, large advertisement, back-lit on a train station wall.

In *The Society of the Spectacle*, Guy Debord describes our current environment as one in which "the real world is replaced by a selection of images . . . projected above it, . . . which at the same time succeed in making themselves regarded as the epitome of reality." Certainly, we are surrounded today by images and the memories of images, and they continue to purvey some shining idea of what families, mountains, and exotic places are supposed to look like, and how they are supposed to make us feel.

Colorama images were subsumed by their predictability and epic size into a mythic taxonomy. These long-gone, oversized advertisements for memory have permanently affected our notions of past and present. Like pentimenti, the ghosts of Colorama persist in our collective consciousness, continuing to shape how and what we see and desire, decorating the walls of some lost and immaterial place that remains longed for, and imperfectly recalled.

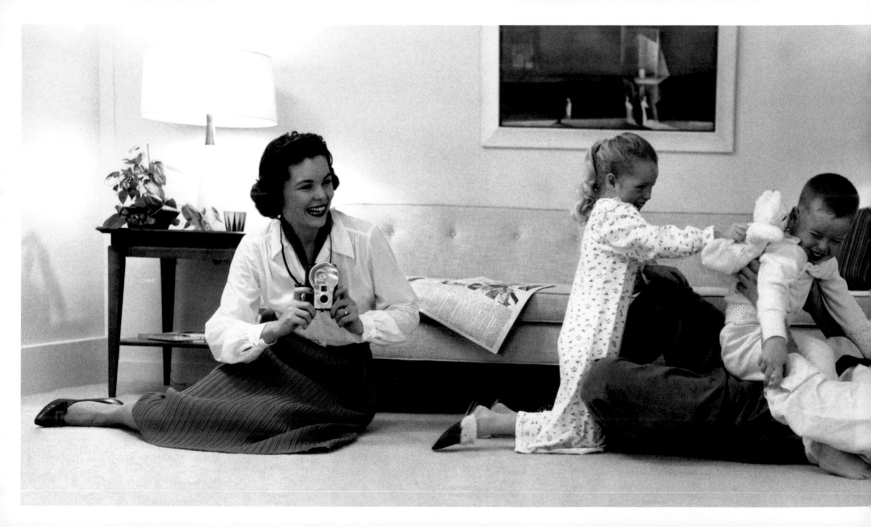

american dream

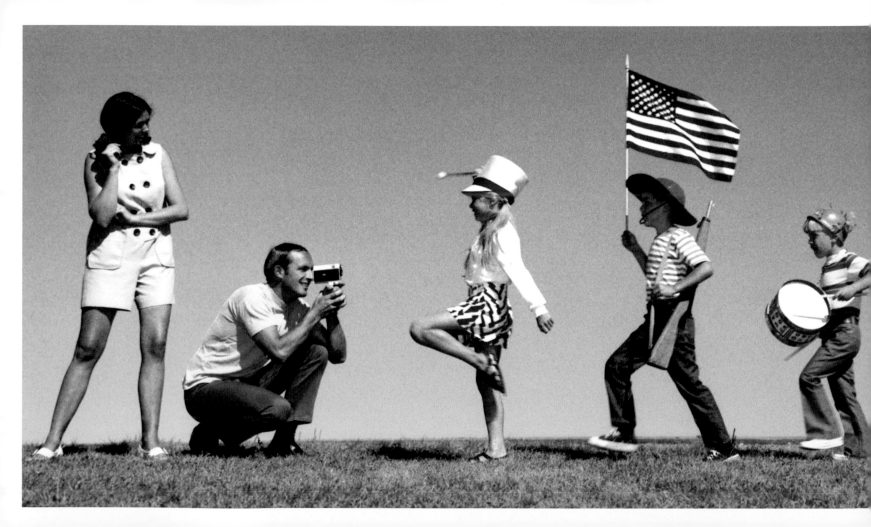

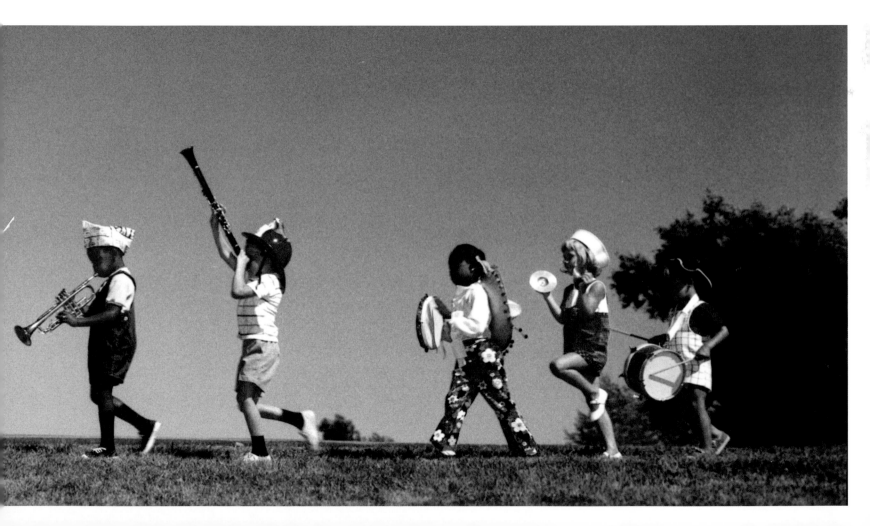

Family outing,
New Canaan, Connecticut.
Colorama #207
by Lee Howick and Phoebe Dunn,
July 1962

Pages 12–13:
Family romp in living room.
Colorama #149 by Lee Howick,
January 1959

Pages 14–15:
Children's parade.
Colorama #339 by Lee Howick,
May 1970

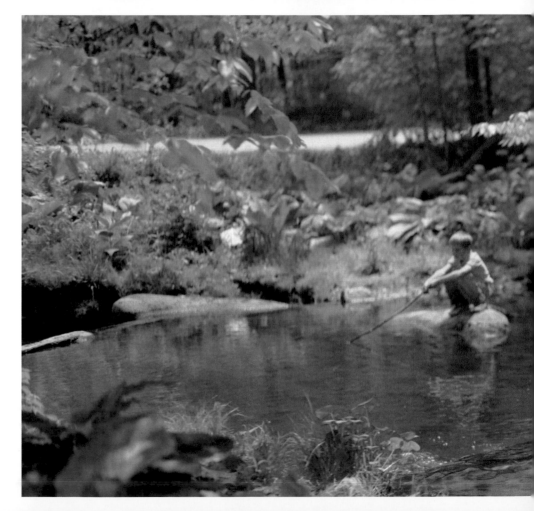

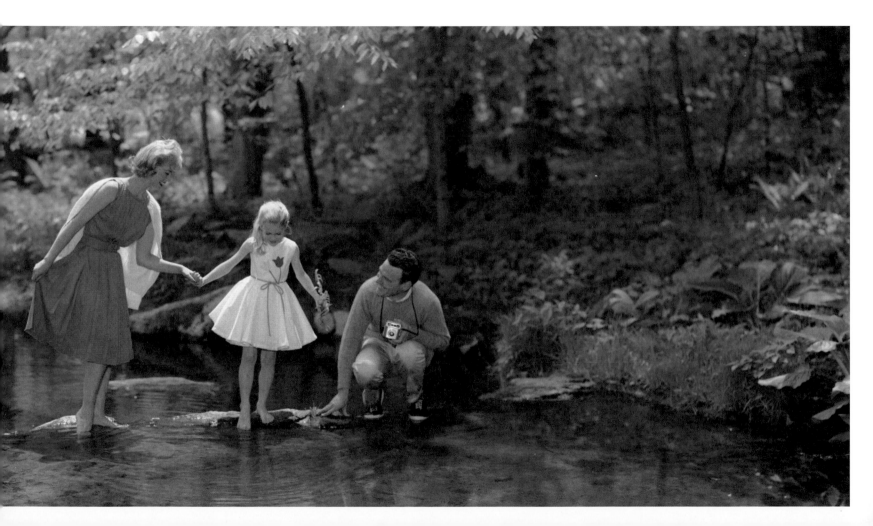

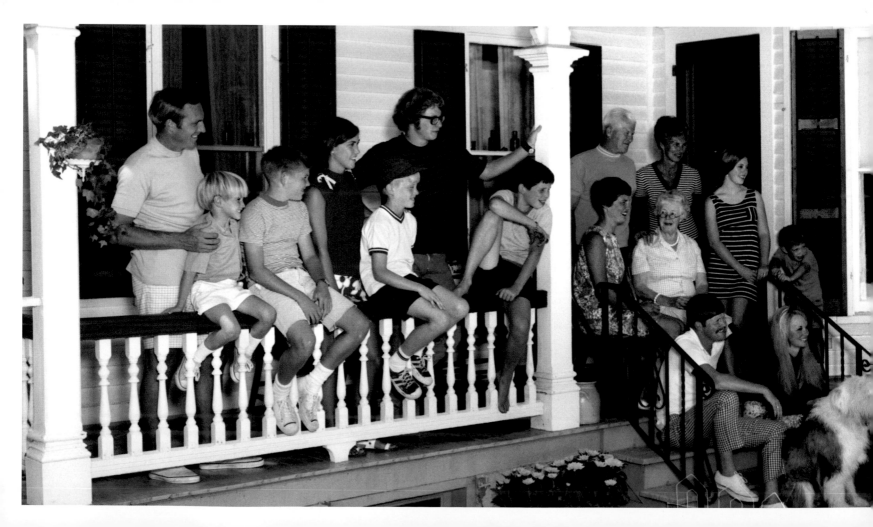

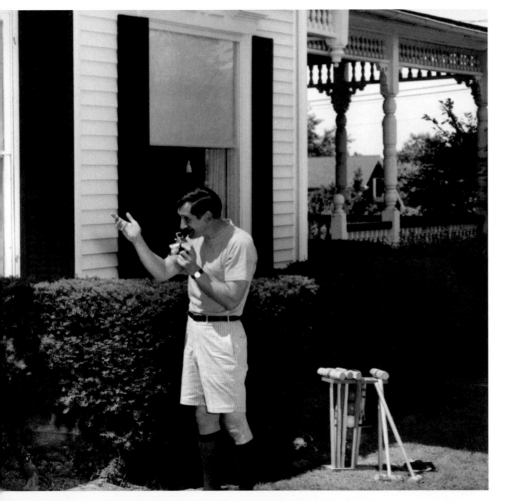

Family reunion.
Colorama #342 by Norm Kerr,
July 1970

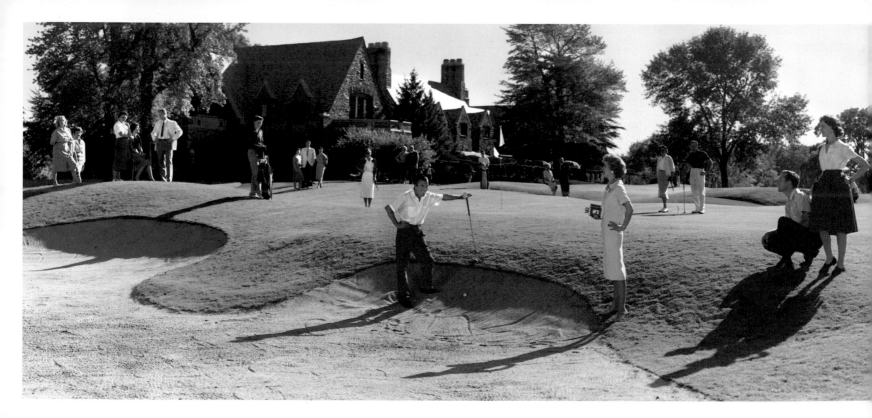

Ed Sullivan at the Winged Foot Golf Course,
Mamaroneck, New York.
Colorama #153 by Herb Archer,
June 1959,
courtesy Elizabeth Sullivan Precht

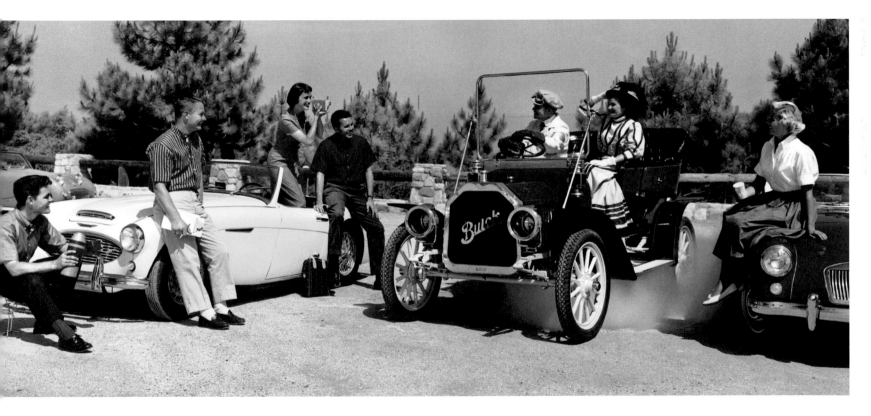

Sports and antique car rally,
Pasadena, California.
Colorama #156 by Peter Gales,
August 1959

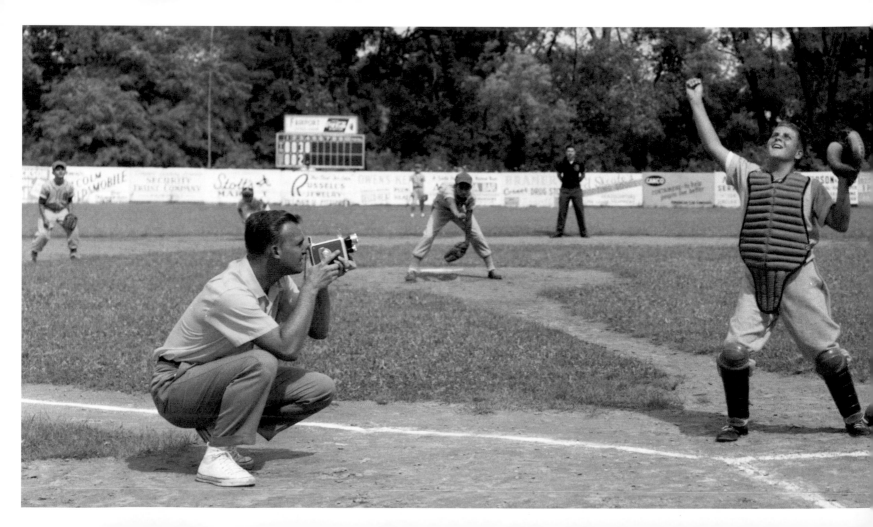

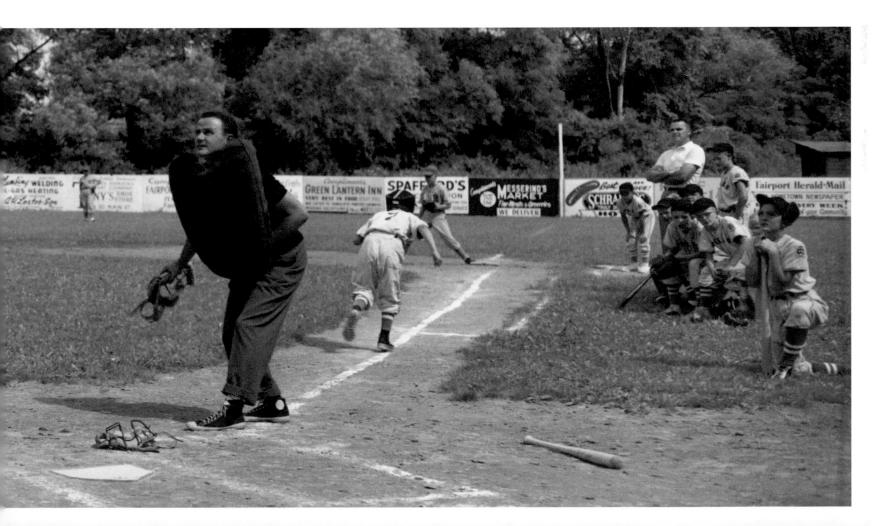

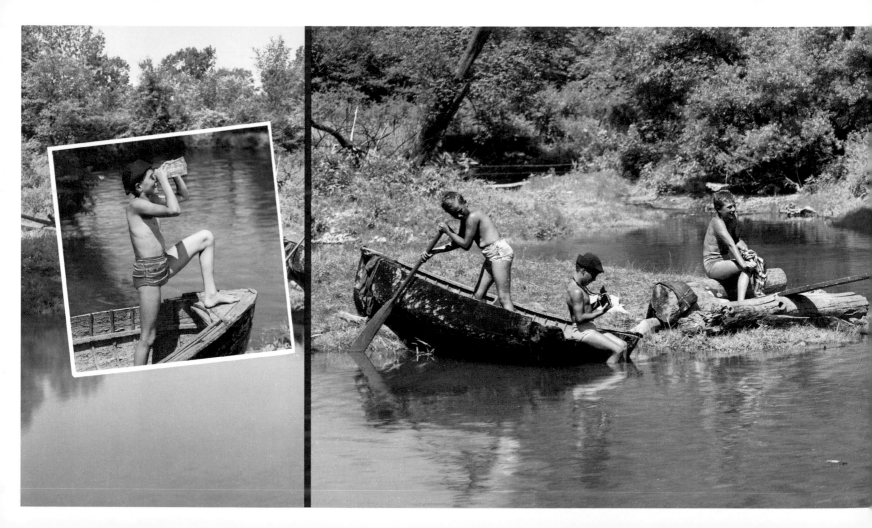

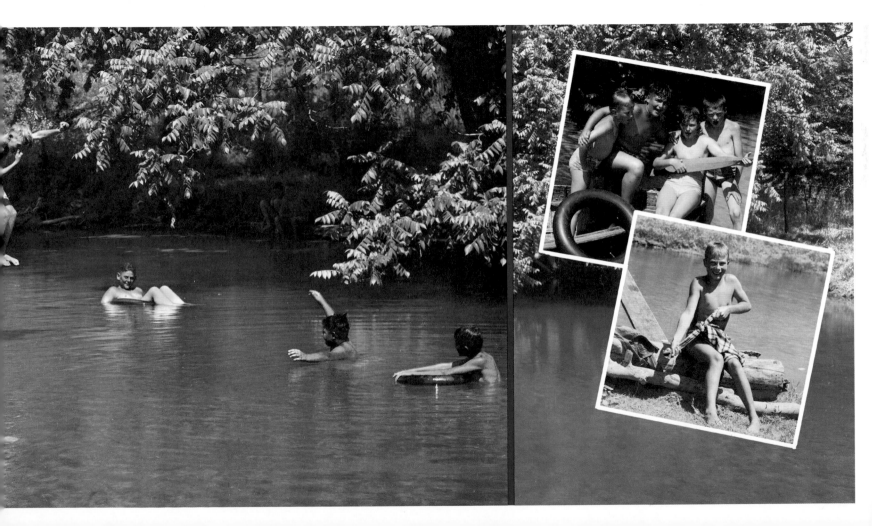

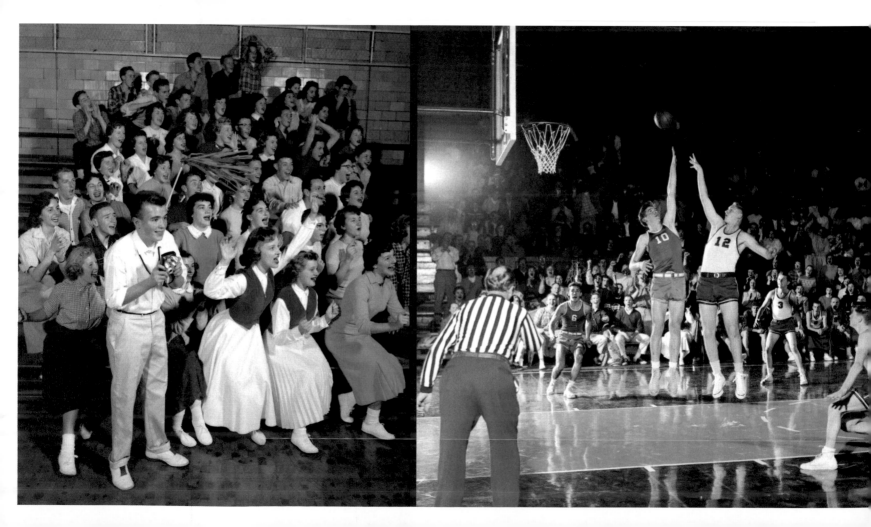

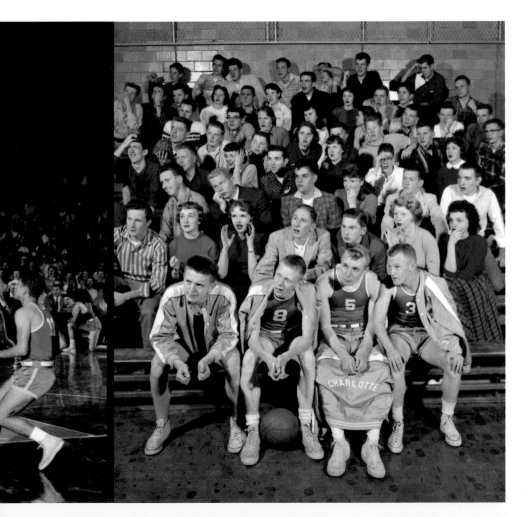

High school basketball game,
Rochester, New York.
Colorama #132 by Wes Wooden,
February 1958

Pages 22–23:
Little league game,
Fairport, New York.
Colorama #124 by Herb Archer,
July 1957

Pages 24–25:
The old swimming hole,
Scottsville, New York.
Colorama #56 by Herb Archer,
June 1953

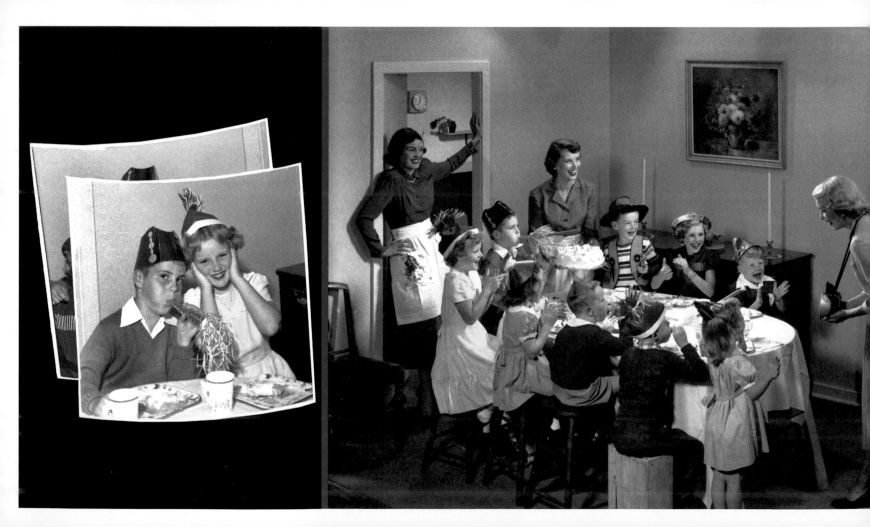

Birthday party.
Colorama #28 by Wes Wooden,
November 1951

29

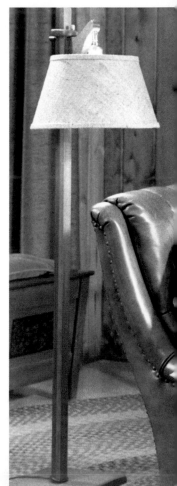

Family story time.
Colorama #252 by Norm Kerr,
March 1965

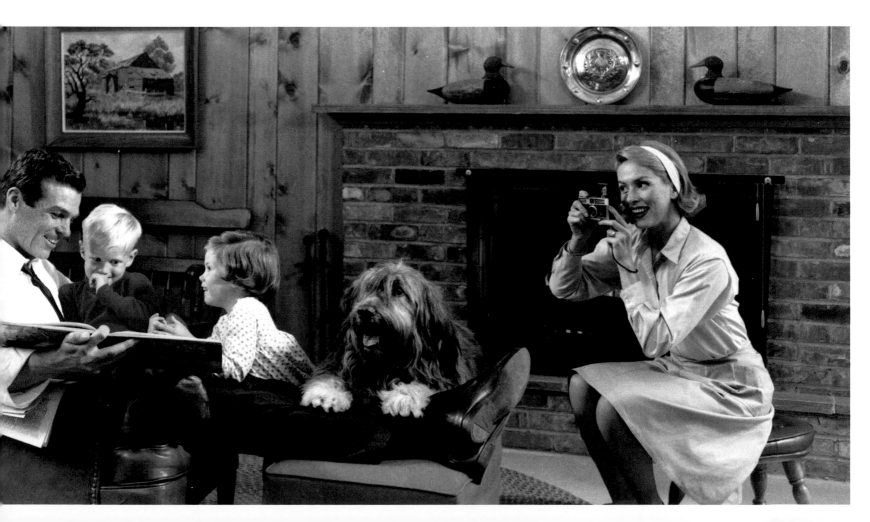

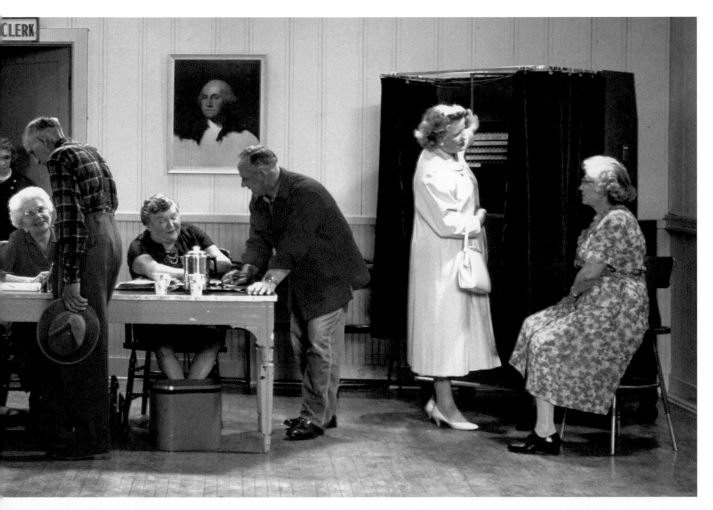

Voting day in Clarkson,
New York.
Colorama #176 by Bob Phillips,
October 1960

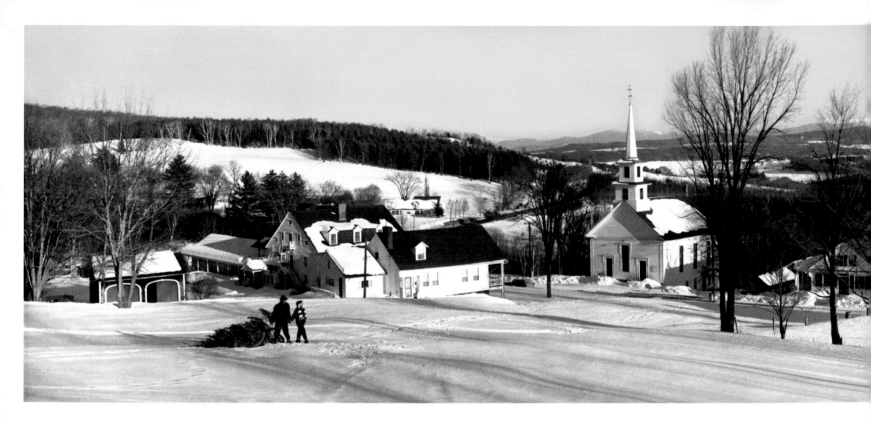

"Season's Greetings—Eastman Kodak Company"
Colorama #162 by Herb Archer,
December 1959

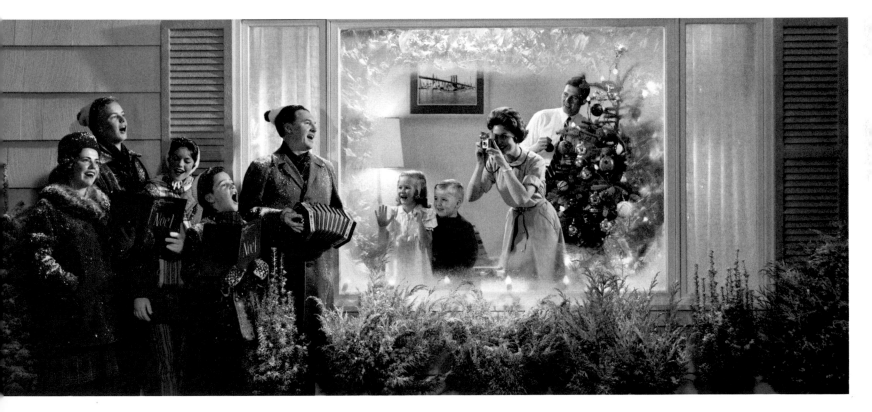

Christmas carolers.
Colorama #195 by Neil Montanus,
December 1961

Teen kitchen party.
Colorama #116 by Bob Phillips,
February 1957

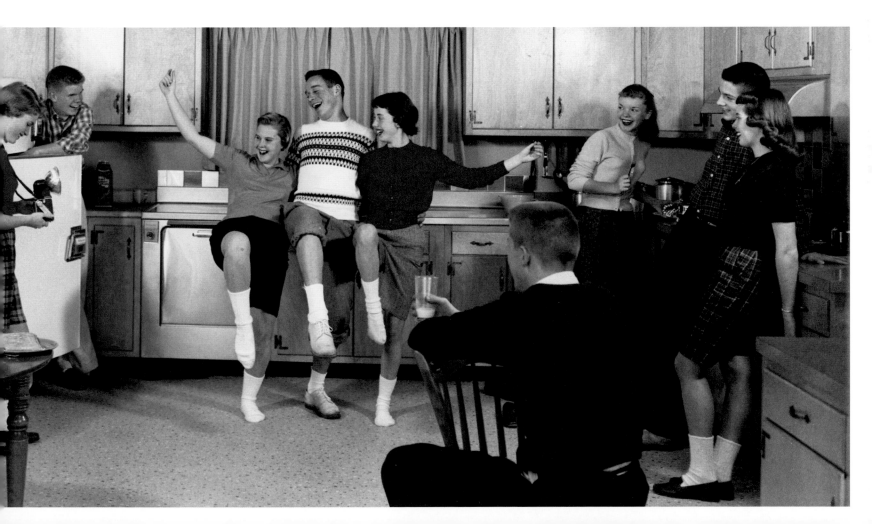

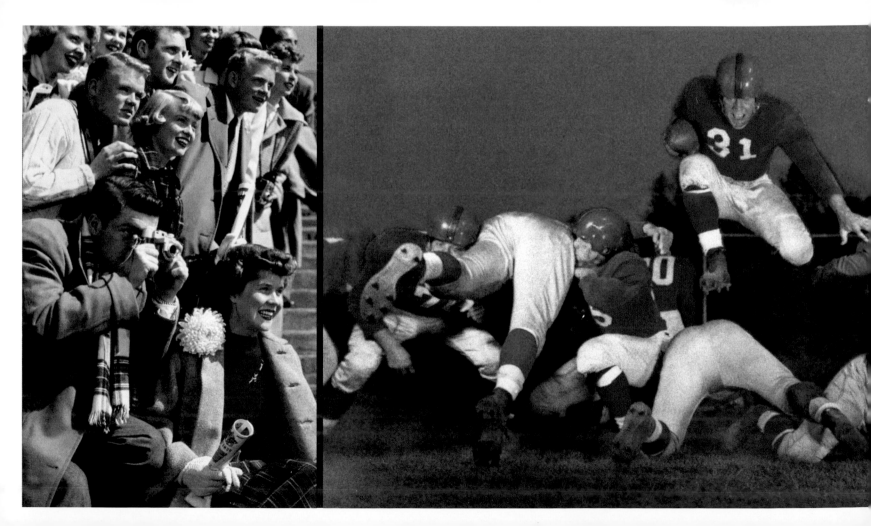

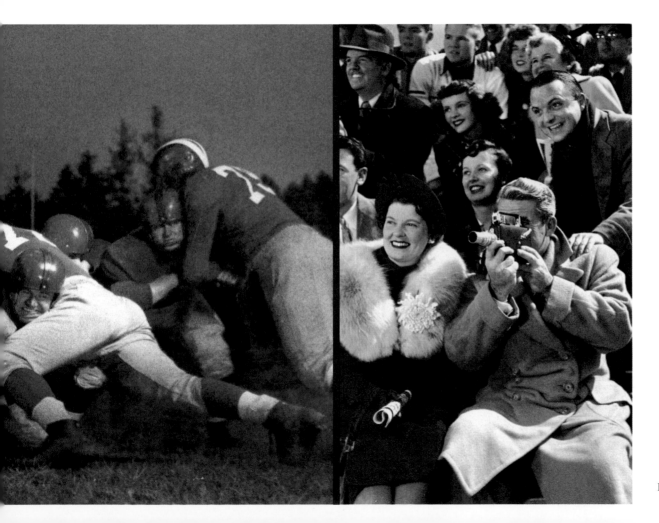

New York Giants spring training,
Lake Tupper, New York.
Colorama #8
by Hank Mayer and Stewart Comfort,
October 1950

39

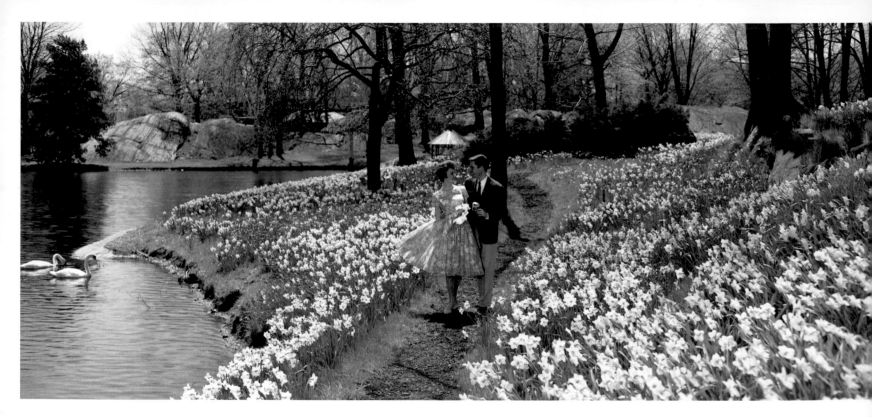

Gonzales Garden, Rye, New York.
Colorama #201 by Lee Howick,
March 1962

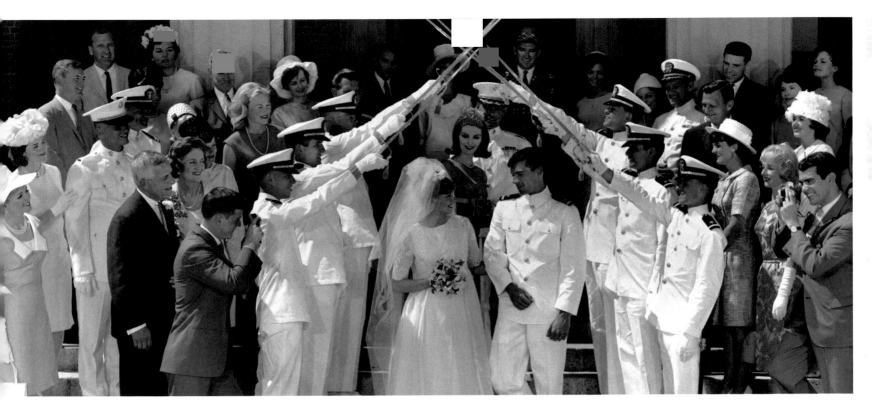

Naval Reserve Officer Training Corps wedding.
University of Rochester Chapel, Rochester, New York.
Colorama #273 by Ray Holden,
June 1966

nothing but
blue skies

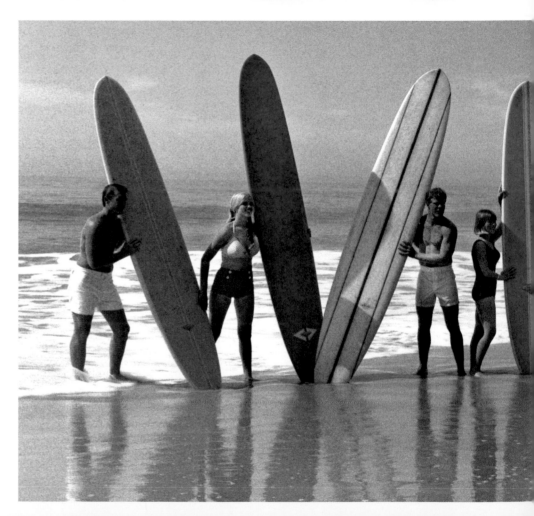

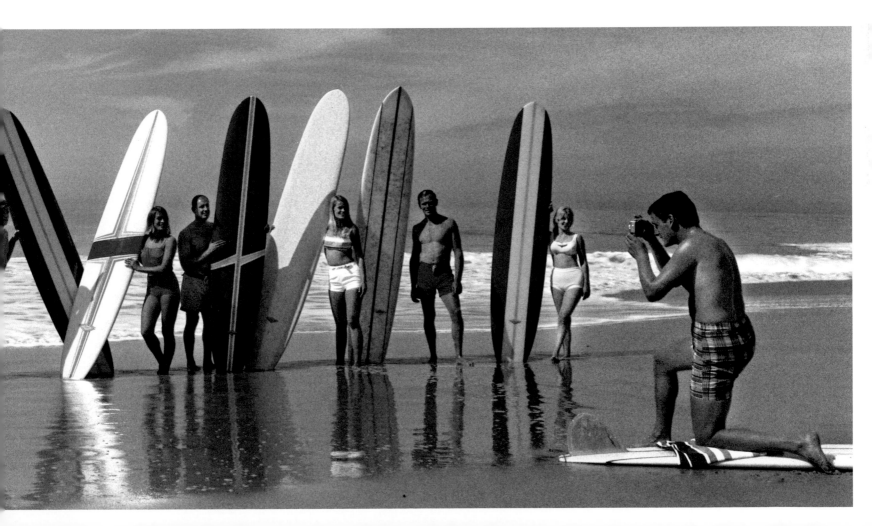

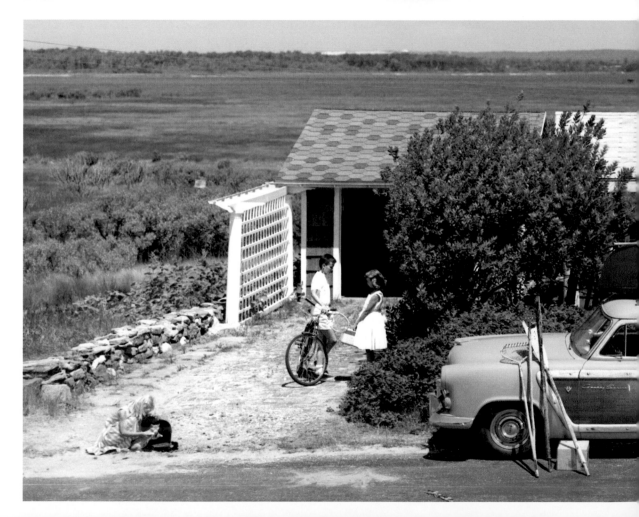

Closing a summer cottage,
Quogue, New York.
Colorama #126
by Ralph Amdursky and Charles Baker,
art direction by Norman Rockwell,
September 1957

Pages 42–43:
Surfers at Long Beach, California.
Colorama #274 by Peter Gales,
June 1966

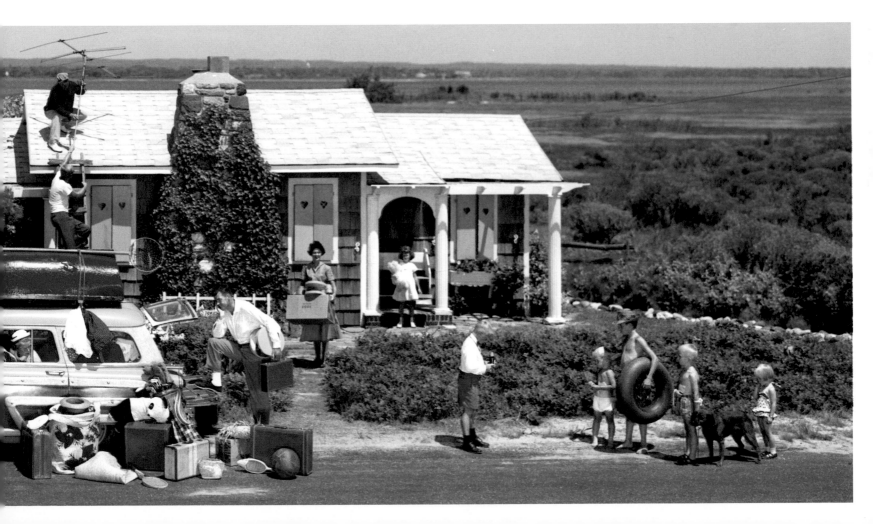

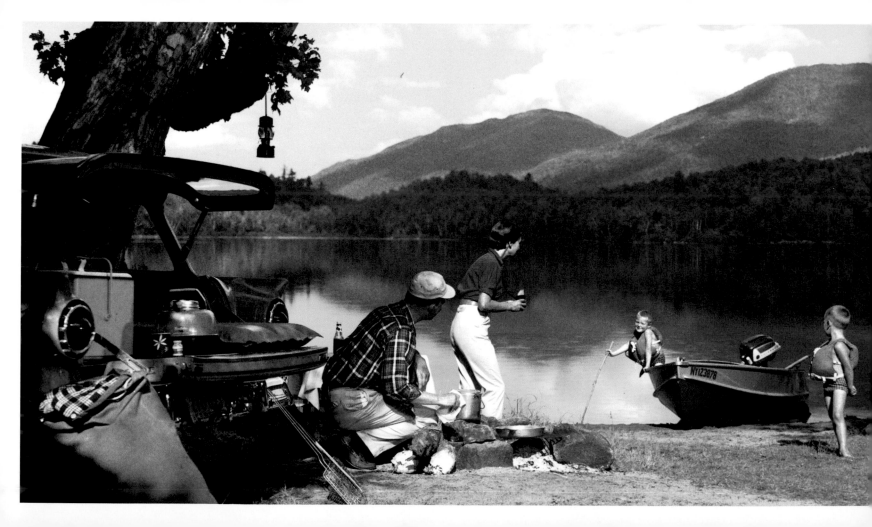

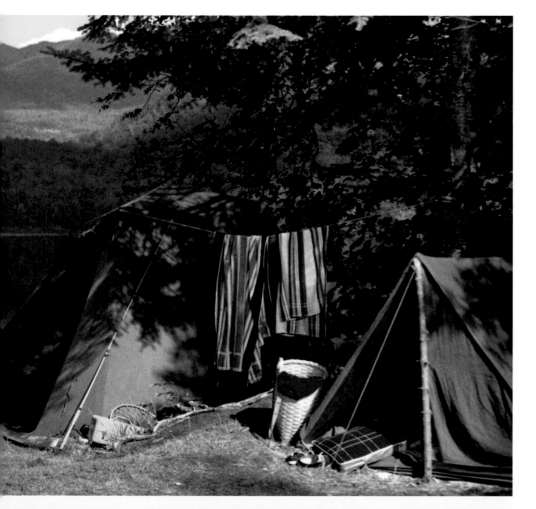

Camping at Lake Placid, New York.
Colorama #155 by Herb Archer,
July 1959

47

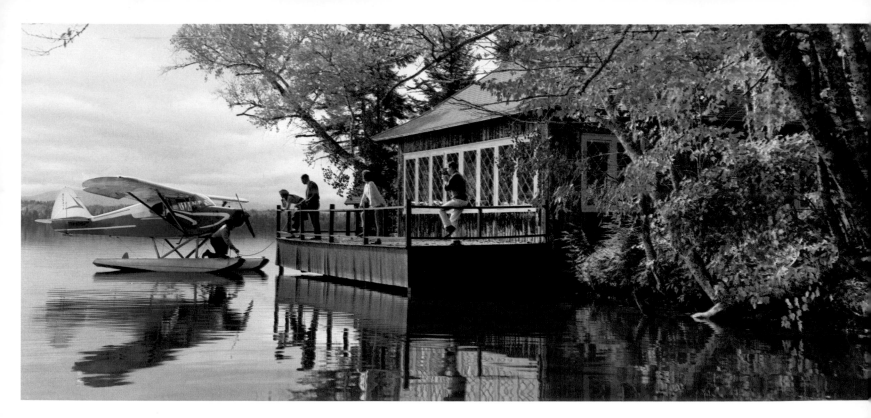

Autumn in the Adirondaks.
Colorama #279 by Lee Howick and Neil Montanus,
October 1966

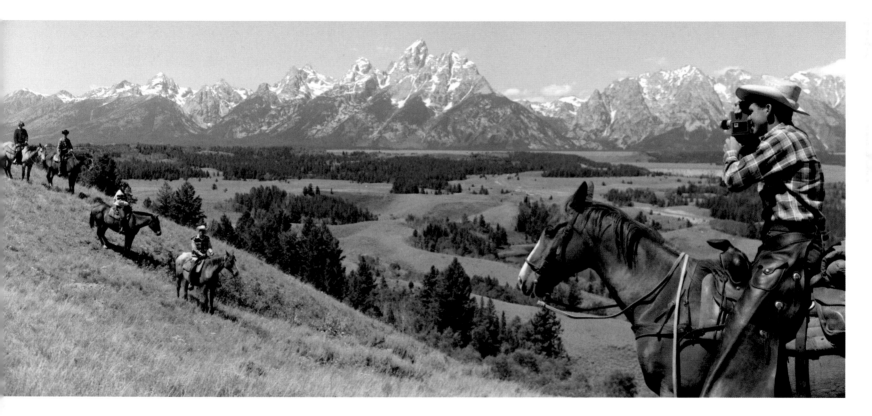

Trail ride in the Grand Tetons, Wyoming.
Colorama #245 by John Hood and Herb Archer,
October 1964

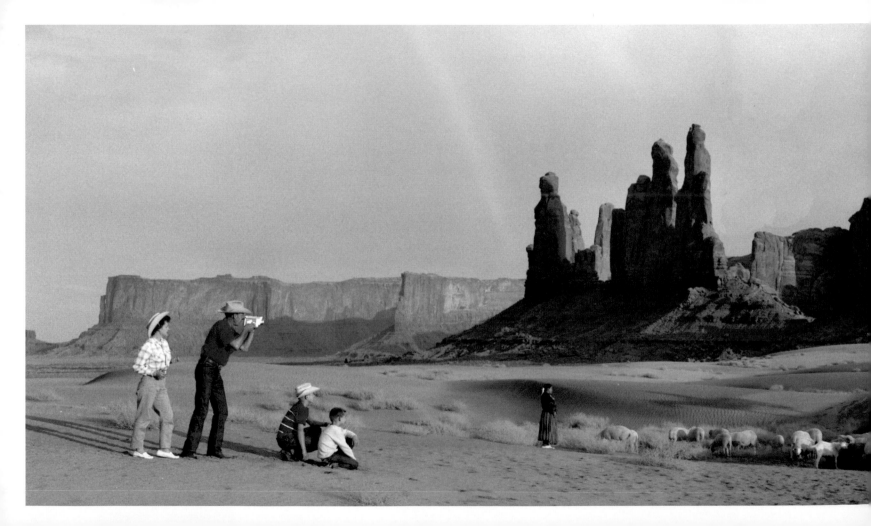

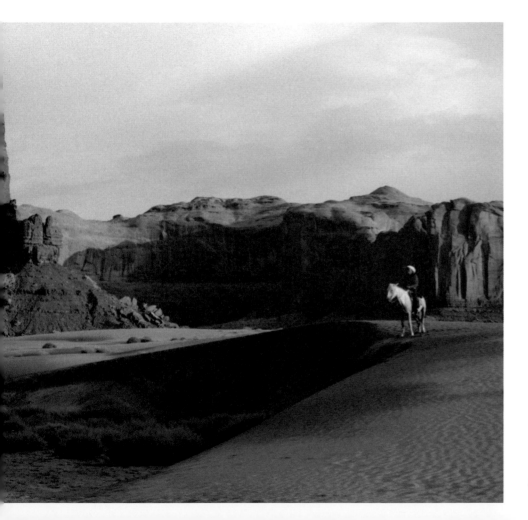

Making movies in
Monument Valley, Arizona.
Colorama #208 by Peter Gales,
August 1962

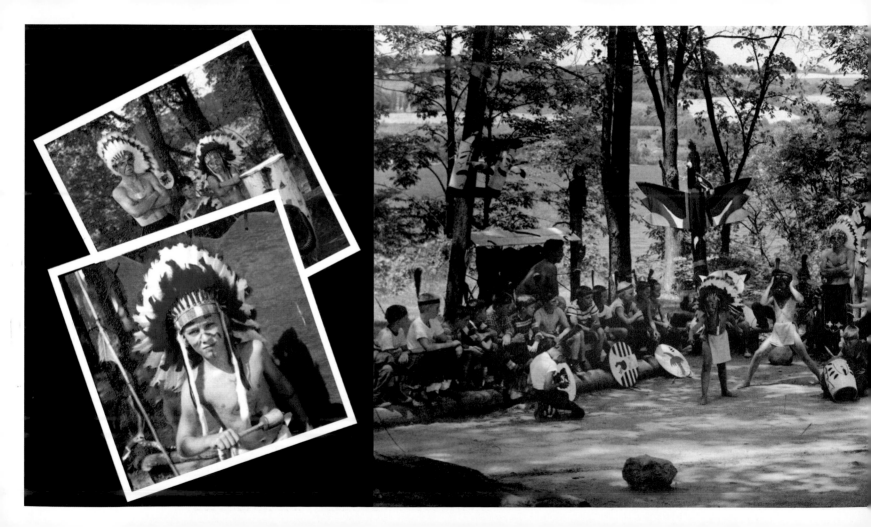

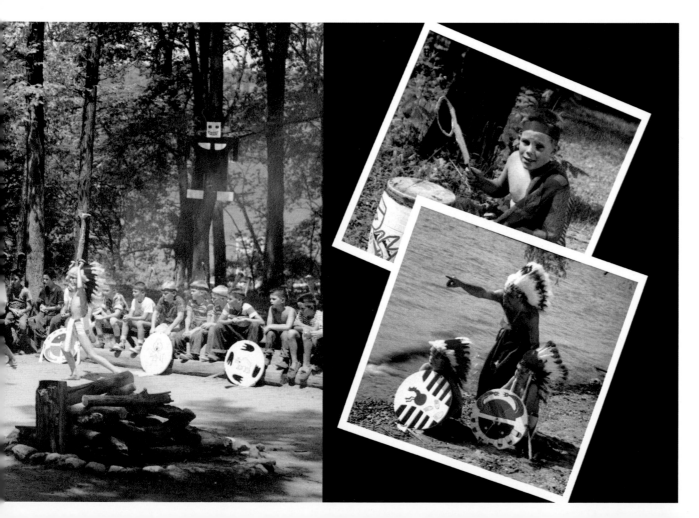

Indian Guides boys' camp.
Colorama #73 by Herb Archer,
June 1954

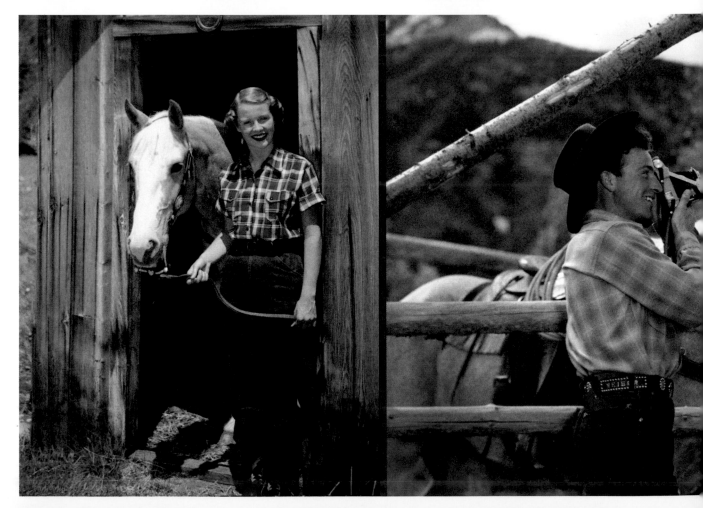

Dude Ranch.
Colorama #21 by Ansel Adams,
July 1951,
courtesy the Trustees of
The Ansel Adams
Publishing Rights Trust

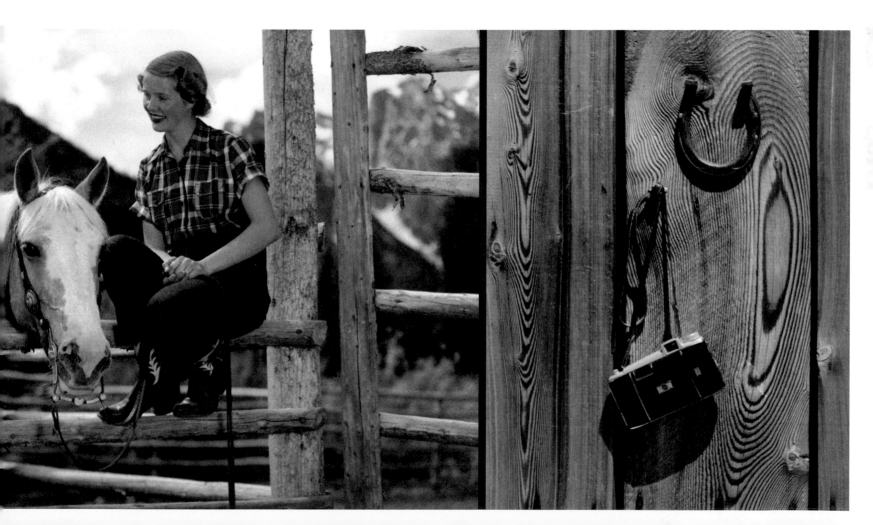

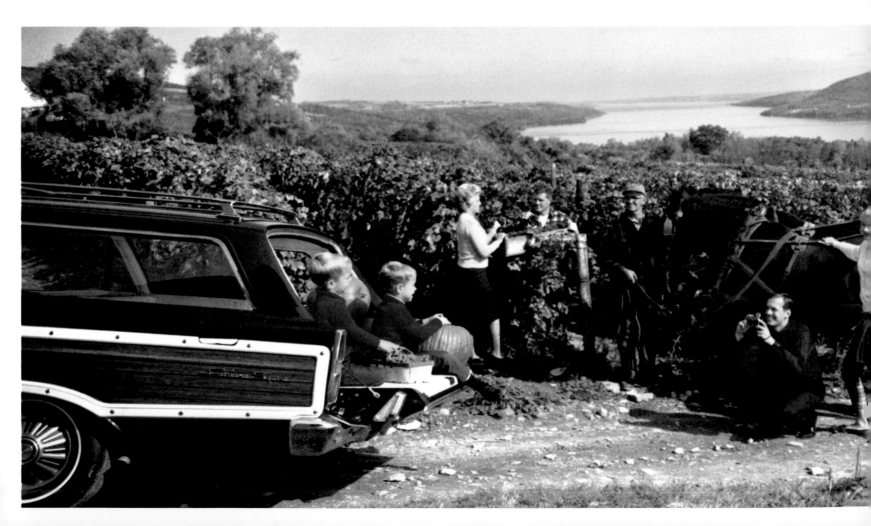

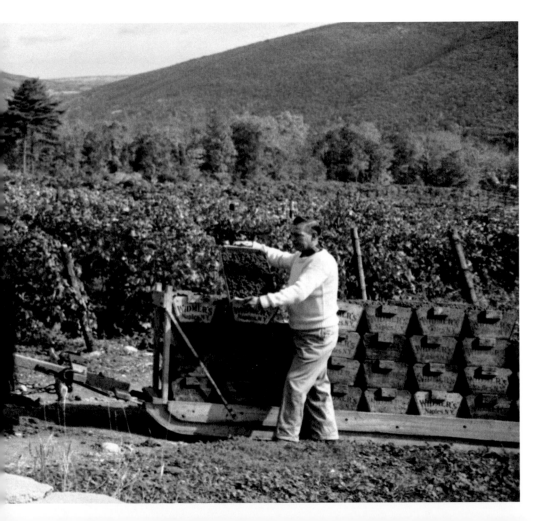

Grape harvest near
Lake Canandaigua, New York.
Colorama #313 by Dick Boden,
October 1968

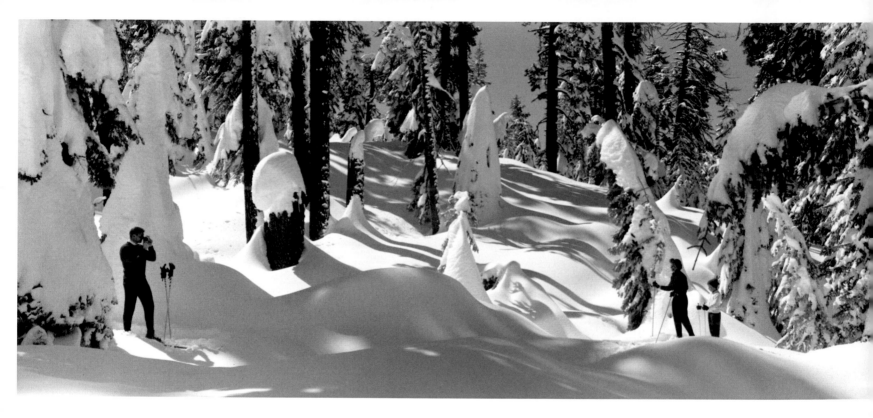

Skiers in Yosemite National Park, California.
Colorama #215 by Ansel Adams,
January 1963,
courtesy the Trustees of
The Ansel Adams Publishing Rights Trust

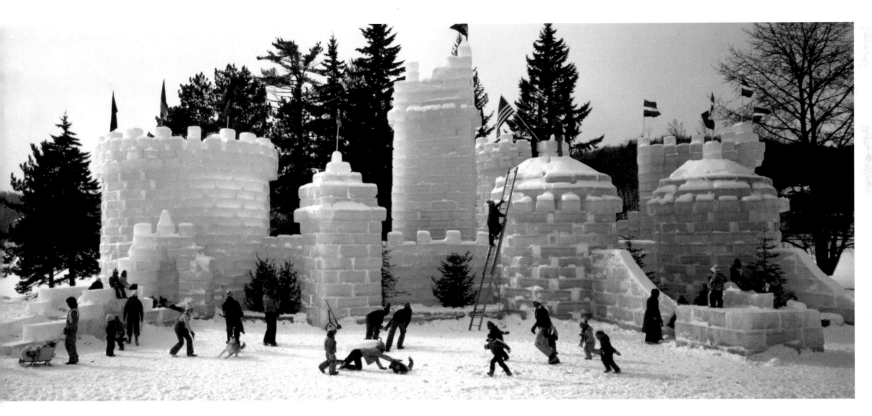

Ice Palace, Saranac Lake, New York.
Colorama #528 by Ozzie Sweet,
February 1986,
courtesy the artist

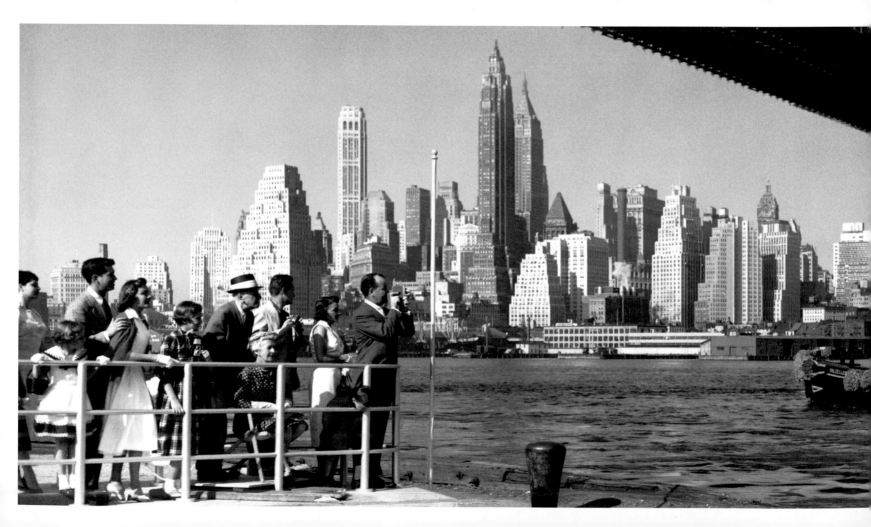

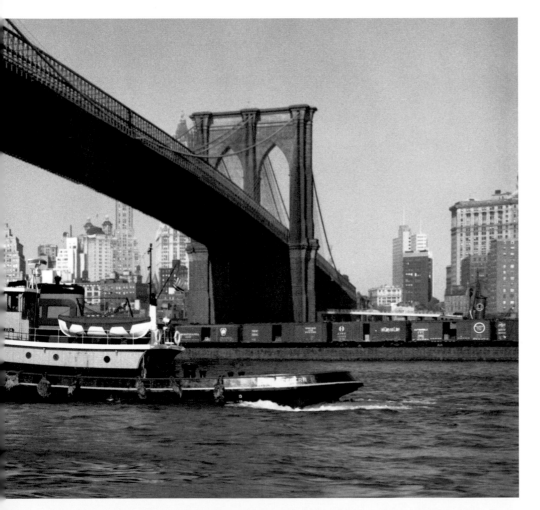

Brooklyn Bridge and
Lower Manhattan, New York.
Colorama #137 by Ralph Amdursky,
May 1958

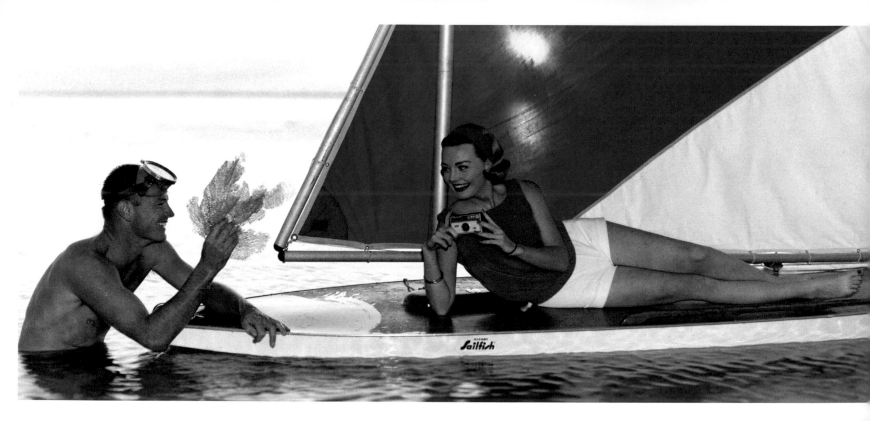

Couple on sailboard, Biscayne Bay, Florida.
Colorama #301 by Norm Kerr,
January 1968

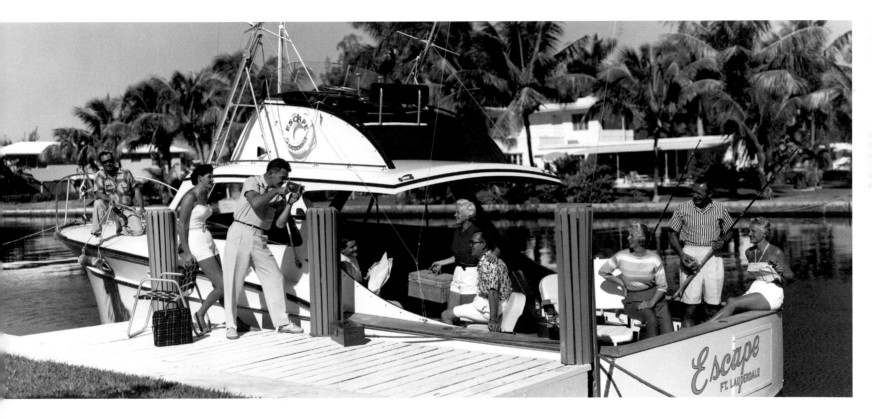

Boating Party, Ft. Lauderdale, Florida.
Colorama #115 by Hank Mayer,
January 1957

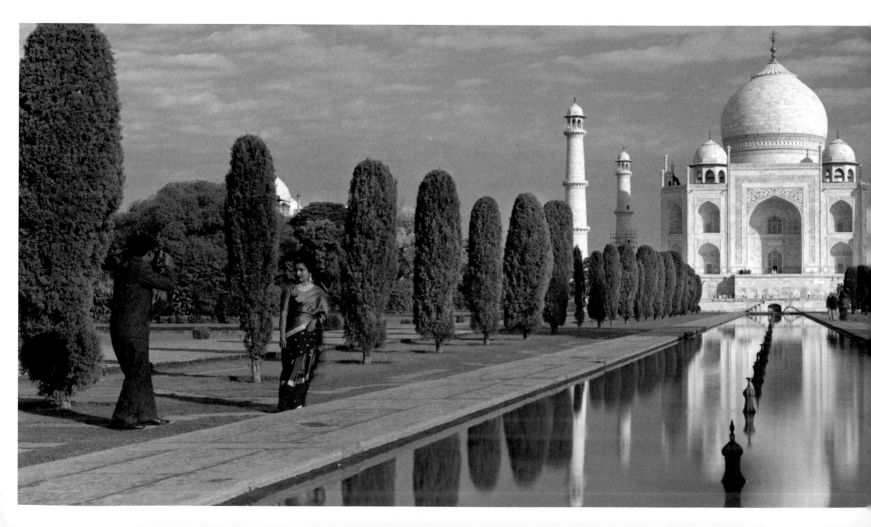

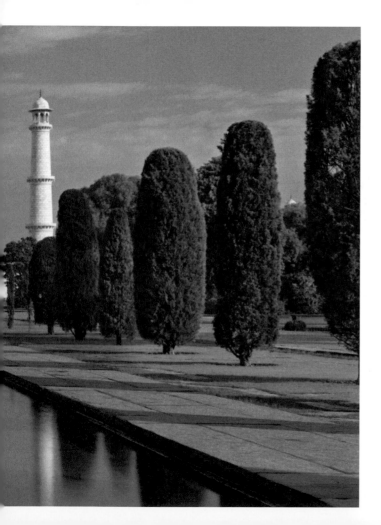

up, up, and away

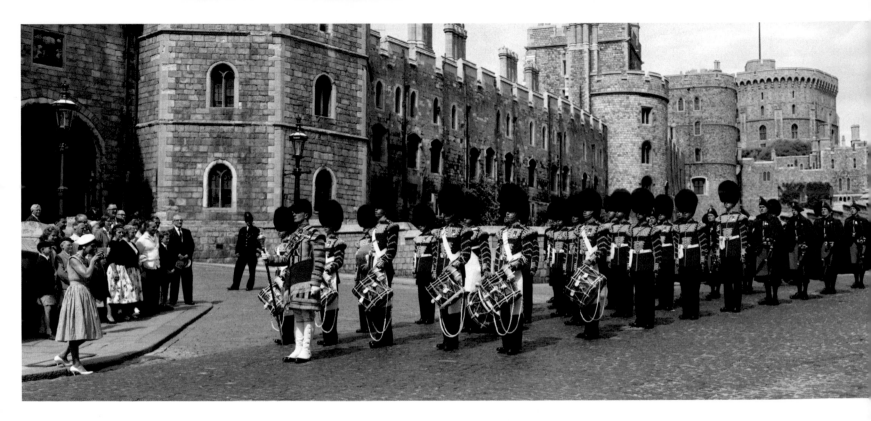

Irish Guard Pipe and Drum Corps at Windsor Castle, Berkshire, England.
Colorama #170 by Lee Howick, June 1960

Pages 64–65:
Taj Mahal, Agra, India.
Colorama #239 by Don Marvin, June 1964

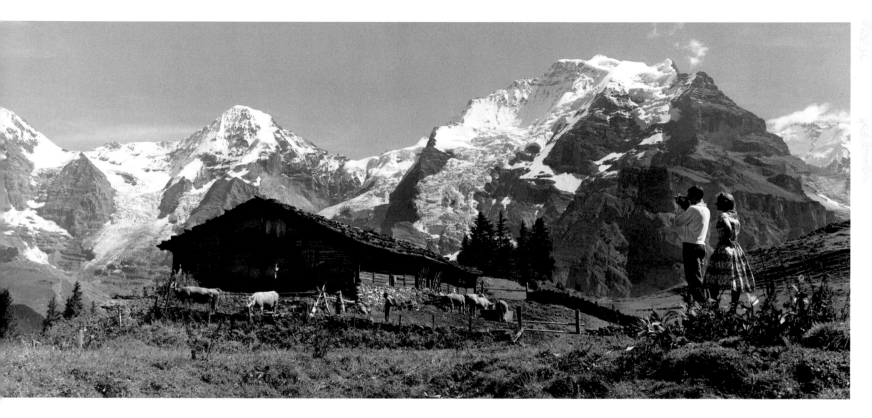

Cabin near the Matterhorn, Switzerland.
Colorama #188 by Lee Howick,
July 1961

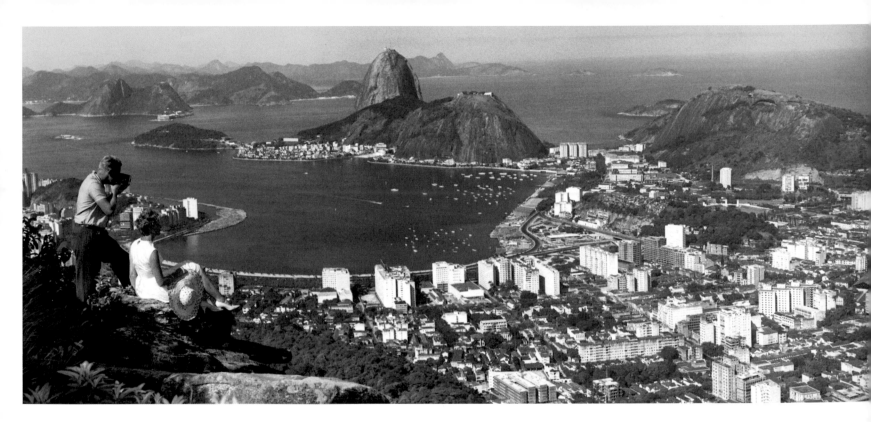

Rio de Janeiro harbor.
Colorama #209 by Herb Archer,
August 1962

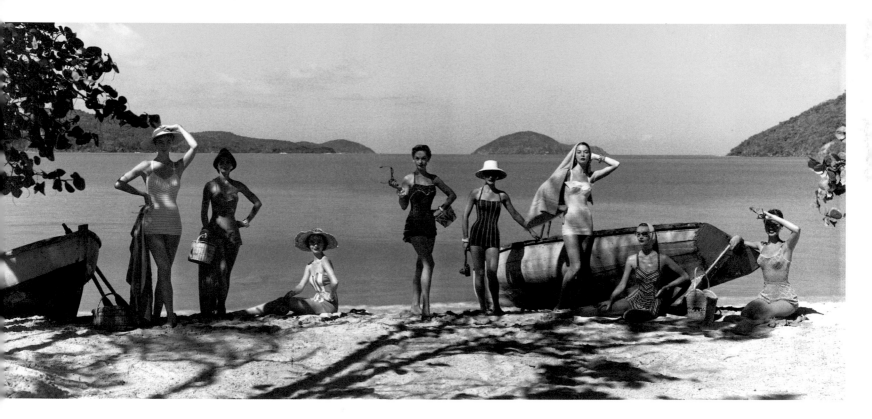

On the beach in the U.S. Virgin Islands.
Colorama #88 by Larry Guetersloh,
May 1955

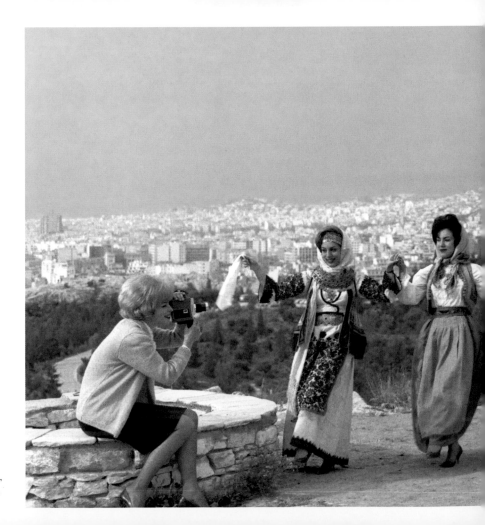

Acropolis dancers.
Colorama #33–40 by Neil Montanus
for Kodak's secondary Colorama program,
not displayed in Grand Central Terminal.
August 1963

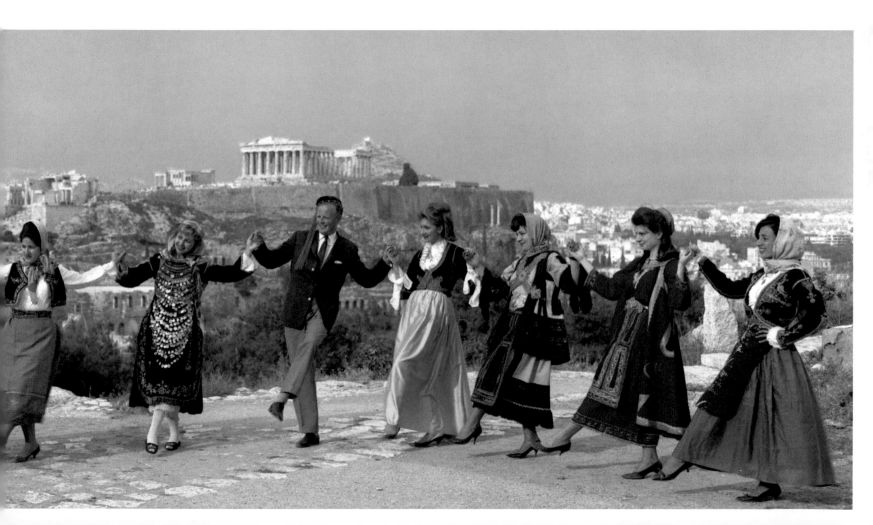

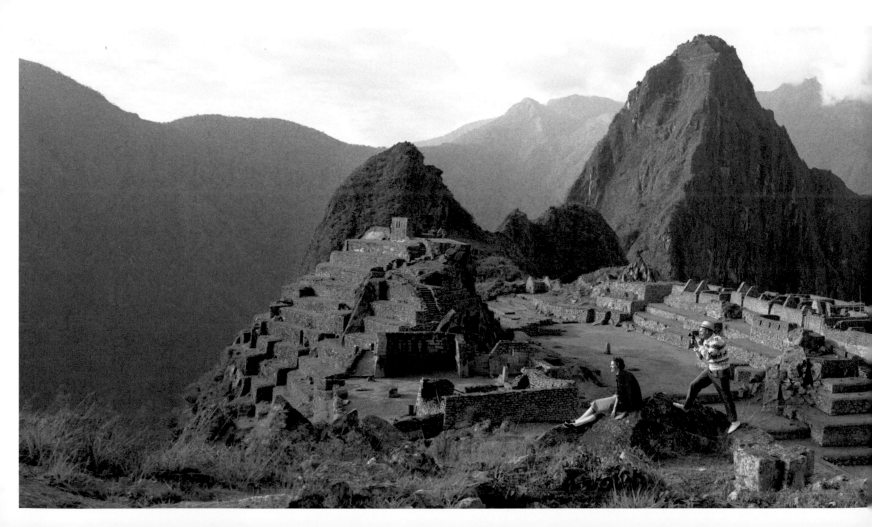

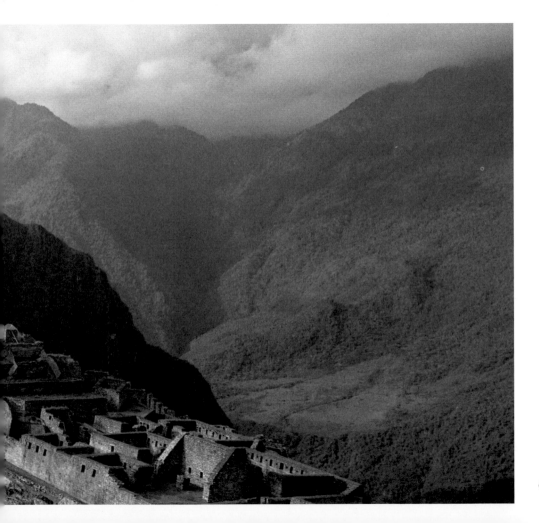

Machu Picchu, Peru.
Colorama #243 by Peter Gales,
August 1964

73

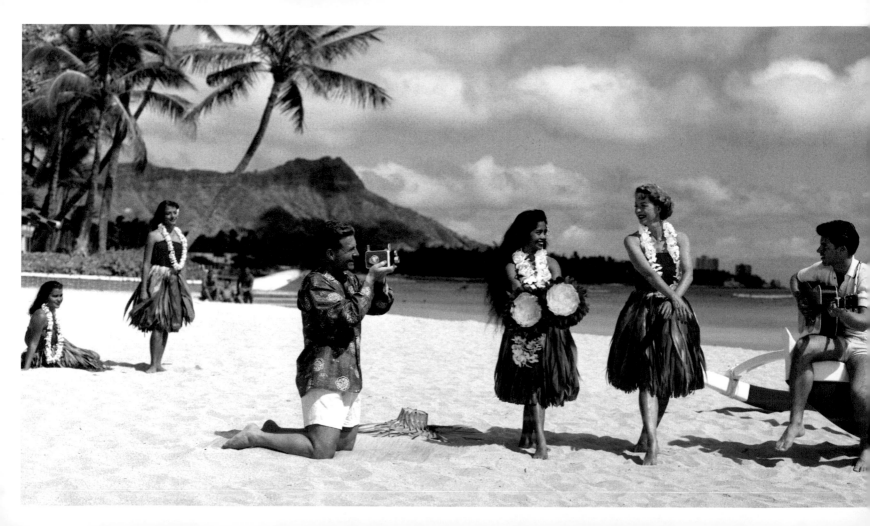

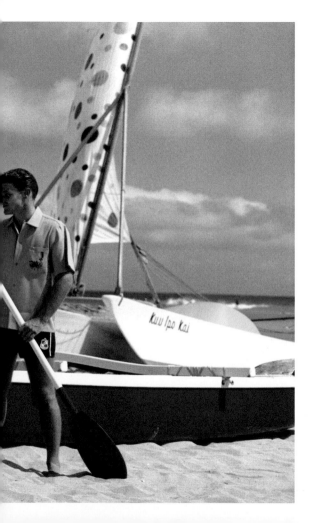

The Ozzie and Harriet Nelson
family at Waikiki Beach, Honolulu, Hawaii.
Colorama #173 by Peter Gales,
August 1960,
courtesy Robert A. Finkelstein /
Estate of Ricky Nelson

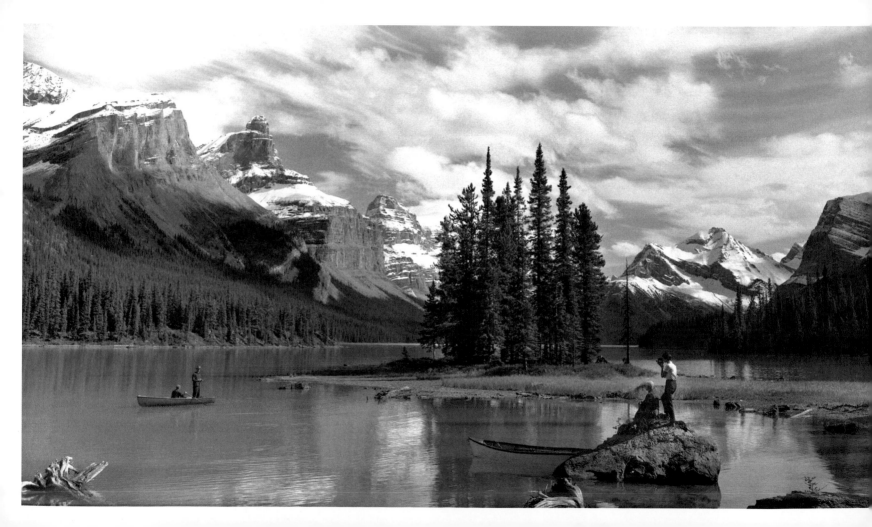

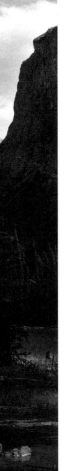

PICTURE PERFECT Peggy Roalf

When the New York Central Railroad offered the Kodak company the colossal east balcony of Grand Central Terminal as advertising space in 1949, color photography represented only 2 percent of Kodak's business. But with the conversion of America's massive military/industrial power to peaceful use, the postwar economic boom brought unprecedented prosperity; the drab wartime era was quickly subsumed into a colorful world inhabited by people who had leisure time and the means to enjoy it. A shiny new suburban lifestyle emerged, accompanied by a flood of even shinier new consumer products. Kodak marketers saw the company's future in placing high-quality, easy-to-use cameras—and color film—into the hands of millions. The Colorama program was launched in May 1950 to promote this initiative, and became one of the most successful product-development and marketing campaigns in corporate history.

At the time, however, the film, the chemistry, and the basic methods for creating 18-by-60-foot-wide backlit transparencies did not yet exist. But Kodak made an enormous leap of faith and quickly developed the technology for producing the Coloramas—and began formulating a series of desirable and affordable cameras for a brand-new audience. Kodak had already set standards for professional color imaging materials, from its dye-transfer process—much loved by advertising designers, and fine-art photographers such as Eliot Porter and William Eggleston—to state-of-the-art film and processing materials for the motion-picture and printing industries. Kodachrome positive transparency film, which had been available since 1935, did not suit the average amateur photographer who wanted color prints. While it yielded brilliant, fine-grained images that made for entertaining slide shows, the production of prints required professional lab services, which were costly. Kodak's research and development lab was given a push in their ongoing search for a viable color print film by a remarkable byproduct of World War II: when American forces seized the Agfa plant at Wolfen, near Leipzig, Germany, the U.S. government claimed the company's trade secrets for Agfacolor negative film as "war indemnity," then distributed the information to film manufacturers (including Kodak's competitors) worldwide. In 1949, Kodak was already working on a new negative-to-positive color

Jasper National Park, Canada.
Colorama #174 by Peter Gales,
August 1960

motion picture film, called the Ektacolor family of products, that would also be used to produce the Coloramas, and would be further developed as print film and paper for the amateur market. By unveiling the Colorama program in conjunction with the development of the Ektacolor color materials for snapshots, which were released in 1955, Kodak took the lead in the amateur photography market.

The first Coloramas consisted of three photographs assembled into a single giant transparency measuring 60 feet across: a 36-foot-wide photograph flanked by two images, each 12 feet wide. The original photographs were created using 8-by-10 and 4-by-5 cameras, which allowed for enlargements up to 50 times the original size without loss of detail. With a specially built enlarger, the negative was exposed onto Kodak's new Ektacolor transparency print film—in 41 sections, each about 20 feet long and 20 inches wide. After processing, the sections were painstakingly spliced together by hand, and joined with transparent adhesive into a single image.

With employees working 16-hour days, under tremendous pressure to produce a new Colorama every three weeks, Kodak's "Rube Goldberg operation" (as it was dubbed by Bill Foley, supervisor of the production team) was gradually refined. Making the exposures for each display was at least a full day's work in almost total darkness. Until 1963, when Kodak built a viscous chemistry processor, the giant transparencies were processed using liquid chemistry. This meant hanging the 20-foot-long wet transparencies to dry overnight in an employee recreation center—the only building on Kodak's Rochester grounds large enough to accommodate Coloramas-in-the-making.

At first, everything about the film, the processing, and the assembly conspired against the result of finished images with a perfectly even tone throughout. This caused serious problems in photographs with broad expanses of blue sky, of which there were many. But the tremendous resources of the company were put to the task. Soon, improved emulsions produced finer-grained and faster films; the Colorama enlarging easel was fitted with a 1,000-watt airport runway light to produce more consistent exposures; and a better method of splicing and rejoining the transparency strips was developed. By the time the first display was unveiled, in May 1950, Kodak's Colorama team had solved the technical problems so skillfully that the basic production methods remained in place for the life of the program.

The slow speed of the early Ektachrome film dictated the use of sophisticated lighting set ups to stop action—even in photographs shot outdoors in bright sunshine. In *Camping at Lake Placid, New York*—a photograph meant to suggest that the viewer, too, could capture family vacation scenes like this with a simple point-and-shoot camera—dozens of disposable flashbulbs supplied enough light to balance the color and detail in the dark foreground with the bright sky and water beyond. By 1977, the speed and fine grain of Kodak's 35 mm films allowed for enlargements that were 150,000 times the size of the original slide.

The images' distinctive panoramic format was first created two years into the program, using a dilapidated, wooden Deardorff banquet camera that took 8-by-20-inch film. The Coloramas were (until the digital age) the world's largest photographs: images 60 feet wide made from a single negative rather than from groups of smaller negatives joined together. The beat-up old camera was eventually replaced by several new, modernized Deardorff panoramics, which became the program's standard for the next 15 years. As improvements were made in film and processing, an array of professional and amateur cameras was also used, ranging from a custom Deardorff 5-by-10 to Kodak's disposable 35 mm panoramic Stretch Camera, which was introduced in 1989, with just about every other type of camera imaginable in between.

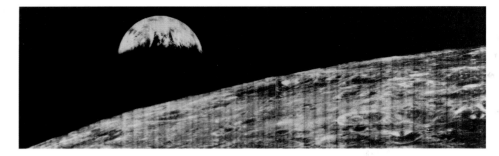

Earthrise from the Moon. Colorama #284, courtesy NASA. January 1967

While the Coloramas' nostalgic view of an American life drenched in sunshine changed little over the program's 40-year run, Kodak's product development progressed at a heroic pace. Many of the new cameras—and their brand names—capitalized on space-age technology and the allure of space travel. In 1957, the year the Soviets launched Sputnik I, Kodak introduced the Starmatic family of cameras; a Christmas Colorama promotion launched the line, which became so popular that 10 million of these automatic, electric-eye cameras were sold over the next five years. In January 1967, the first photograph of the earth viewed from the moon, photographed by NASA's Lunar Orbiter I on Kodak film, filled the display station. And in 1969, New Yorkers passing through Grand Central saw a Colorama of the first moon landing, a day before the Apollo 11 pictures were seen in the weekly news magazines. By 1972, the Instamatic Camera, of which more than 50 million had already been produced, was miniaturized to pocket size. In 1981, the company introduced Ektaflex color printmaking kits for home darkroom enthusiasts. In 1990, the year the Colorama program ended, Kodak announced the development of the Photo CD and proposed a universal system for defining color throughout the digital environment.

The very last Colorama, which was displayed from November 1989 to February 1990, is now steeped in a nostalgia that has altered the photograph's original meaning since the events of September 11, 2001. In this picture, a glittering nighttime view of the New York City skyline features the Twin Towers of the World Trade Center, with the only digital enhancement ever created for the Colorama program—an oversize red apple nestled among the buildings to the towers' left. The copy that ran with the photograph reads: "Kodak thanks the Big Apple for 40 years of friendship in Grand Central."

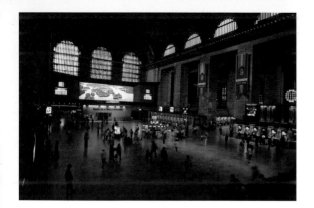

Colorama #553
on display in Grand Central Terminal
from August 15–September 22, 1988.
Photograph by Norm Kerr.

Back cover:
Saturday night bath.
Colorama #234 by Lee Howick,
February 1964

●

Colorama
THE WORLD'S LARGEST PHOTOGRAPHS / An Aperture Foundation Book

Library of Congress Control Number: 2004107958
Hardcover ISBN: 1-931788-44-8
Printed and bound by Phoenix Color Corporation, Rockaway Division, U.S.A.

The staff at Aperture for *Colorama*:
Editor: Peggy Roalf
Art Director: Francesca Richer
Production Manager: Bryonie Wise
Design Work-Scholar: Ursula Damm

Ellen S. Harris, *Executive Director*; Roy Eddey, *Director of Finance and Administration*; Lesley A. Martin, *Executive Editor, Books*; Lisa A. Farmer, *Production Director*; Andrea Smith, *Director of Publicity*; Linda Stormes, *Director of Sales & Marketing*; Diana Edkins, *Director of Special Projects*; Andrew Hiller, *Acting Managing Editor*; Lea Golis, *Editorial Work-scholar*; Julie Schumacher, *Production Work-scholar*

Aperture Foundation would like to extend special thanks to: Anthony Bannon, Dan McCormick, and Sean Corcoran at the George Eastman House for bringing the Colorama collection to our attention and for their help in launching the project; Robert Croog, Gary Vangrafeiland, and Michael McDonald at Kodak for their support of the project; Phil Huge at Kodak for his expertise in preparing the photographs for publication; and Giorgio Bracaglia of Evolution Impressions for restoration work on several early Coloramas. We would also like to thank Norman Kerr, whose notes on the Colorama's history have been an invaluable resource.

Aperture Foundation, a not-for-profit organization, publishes *Aperture* magazine, books, and limited-edition prints of fine photography and presents photographic exhibitions worldwide. A complete catalog is available on request.

Aperture Customer Service: 20 East 23rd Street, New York, New York 10010. Phone: (212) 598-4205. Fax: (212) 598-4015. Toll-free: (800) 929-2323. E-mail: customerservice@aperture.org

Aperture Foundation, including Book Center and Burden Gallery: 20 East 23rd Street, New York, New York 10010. Phone: (212) 505-5555, ext. 300. Fax: (212) 979-7759. E-mail: info@aperture.org Visit Aperture's website: www.aperture.org

Aperture Foundation books are distributed outside North America by: Thames & Hudson Distribution, Ltd. Phone: +44(0)1252-541602 Web: www.thamesandhudson.co.uk

To subscribe to *Aperture* magazine write Aperture, P.O. Box 3000, Denville, New Jersey 07834, or call toll-free: (866) 457-4603. One year: $40.00. Two years: $66.00. International subscriptions: (973) 627-2427. Add $20.00 per year.

First Edition
10 9 8 7 6 5 4 3 2 1